PICTURES FROM THE NEW WORLD

PICTURES FROM THE NEW WORLD

photographs and text by
DANNY LYON

APERTURE

Design by Danny Lyon. Composition by Scarlett Letters, New York. Printed by Rapoport Printing Corp., New York. Danny Lyon received grants in photography from the New York State Council for the Arts in 1967, from the John Simon Guggenheim Memorial Foundation in 1969, and from the National Endowment for the Arts in 1972. His photographs are represented by the Simon Lowinsky Gallery in San Francisco, and rights for reproduction are available through Magnum Photos, Inc., New York. The photographs on pages 113 and 115 are published courtesy of Documerica, Environmental Protection Agency, Washington, D.C. Staff for *Pictures from the New World*: Michael Hoffman, editor-publisher; Carole Kismaric, associate editor; Lauren Shakely, managing editor; Stevan A. Baron, production manager; Wendy Byrne, design associate.

Pictures from the New World is available in a numbered collector's edition of 400 copies signed by Danny Lyon. An original silver print signed by the photographer accompanies the collector's edition. *Gloria and Rosario, Santa Marta,* 1972 accompanies numbers 1–200; *Ellis Unit,* 1968 accompanies numbers 201–400.

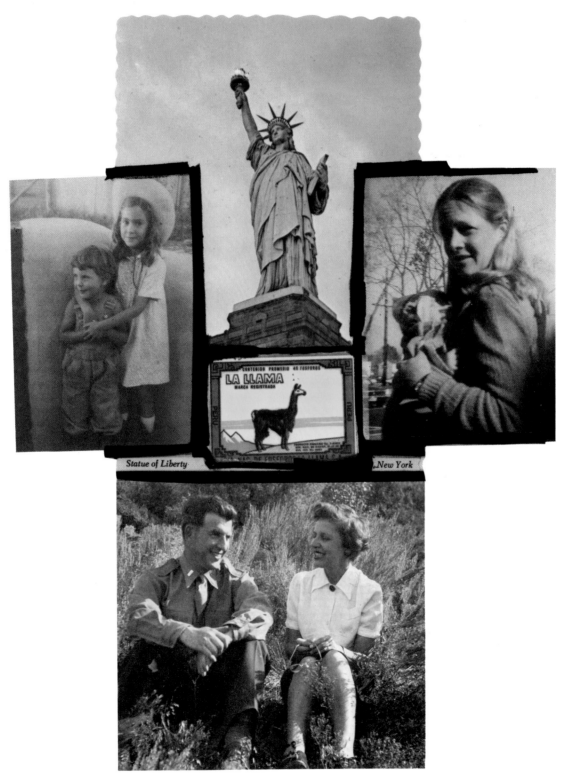

To my parents, Ernst and Beba Lyon

I never intended to be a photographer. I never intended to be anything. In 1962 I was a history student at the University of Chicago. While hitchhiking in the West I took a picture of a truck in the desert and entered it in the Festival of the Arts Exhibit at the university. Hugh Edwards, curator of prints and drawings at the Art Institute of Chicago and one of the judges, gave my picture a prize. He said he liked big trucks. Aaron Siskind was also a judge, and I was told that he said he preferred pregnant women as a subject. Thus early in life the world was divided for me. Photography then seemed new and exciting, and all America, which I regarded with mystery and reverence, lay before me.

Eighteen years have now passed. In order to make this book I have had to face directly everything I have done in photography from that day to this. Now, I give it back to you, America, from whom I took it all in the first place. The slate is clean, and I am free to begin again.

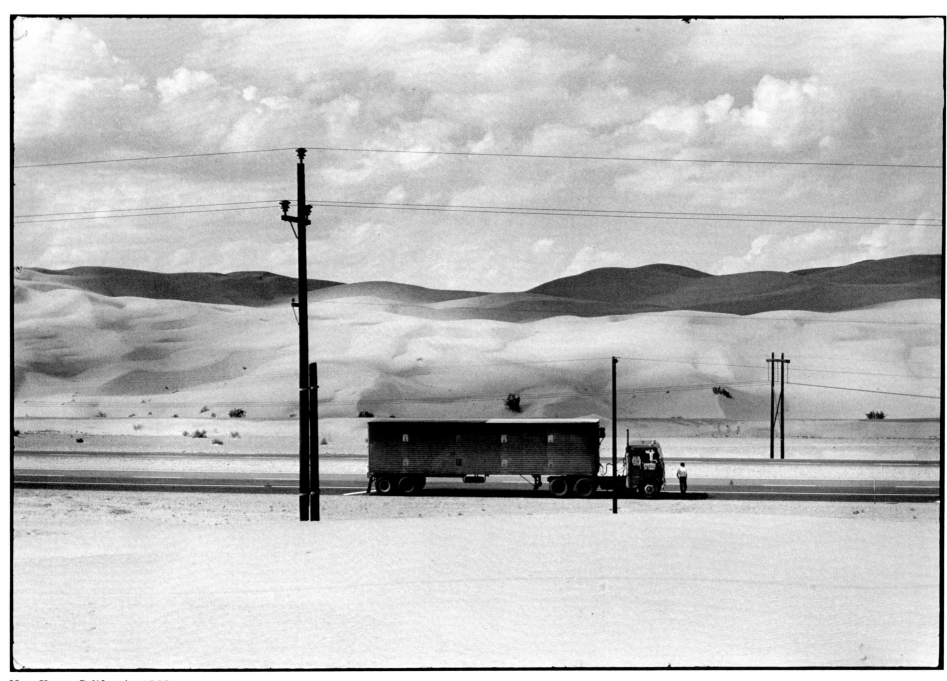

Near Yuma, California, 1962

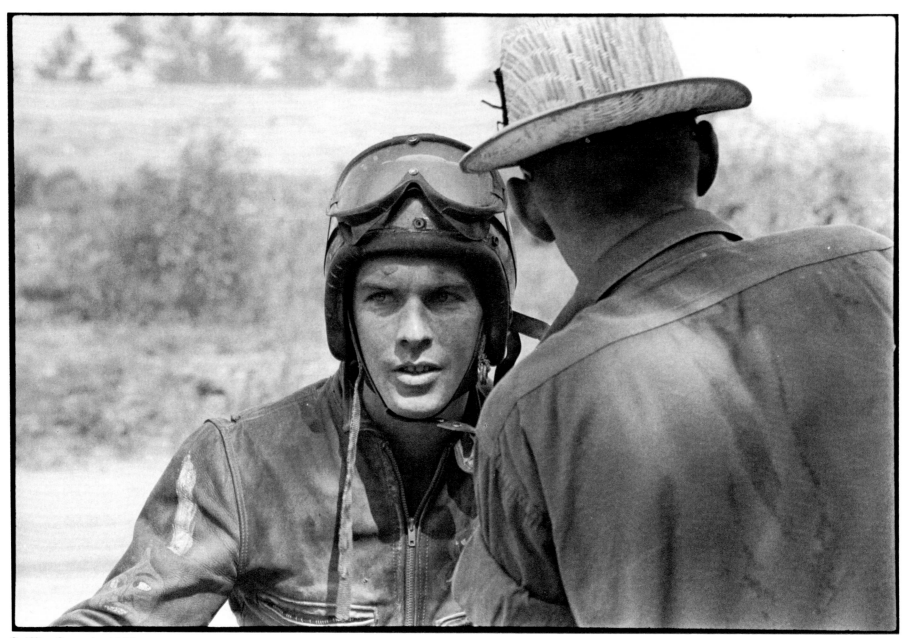

Griffin, Georgia, 1963

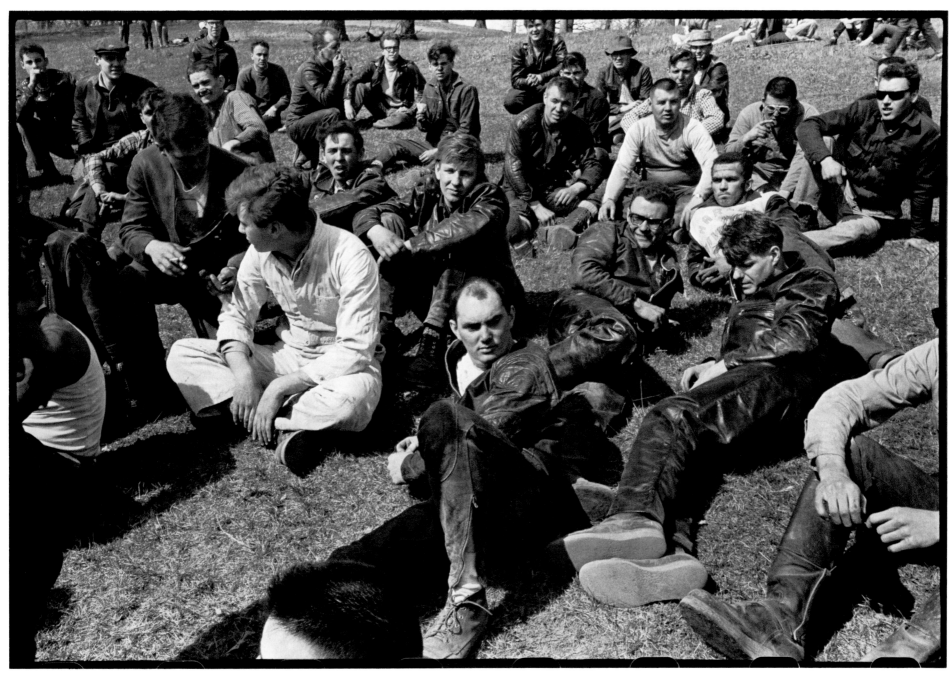

Bikeriders' meeting, Elkhorn, Wisconsin, 1963

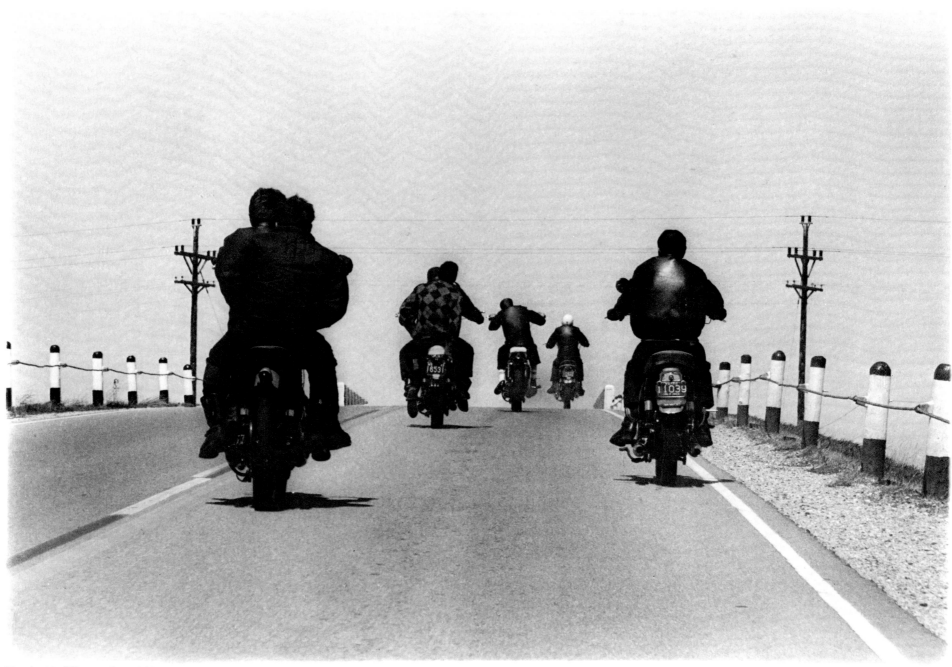

Route 12, Wisconsin, 1963

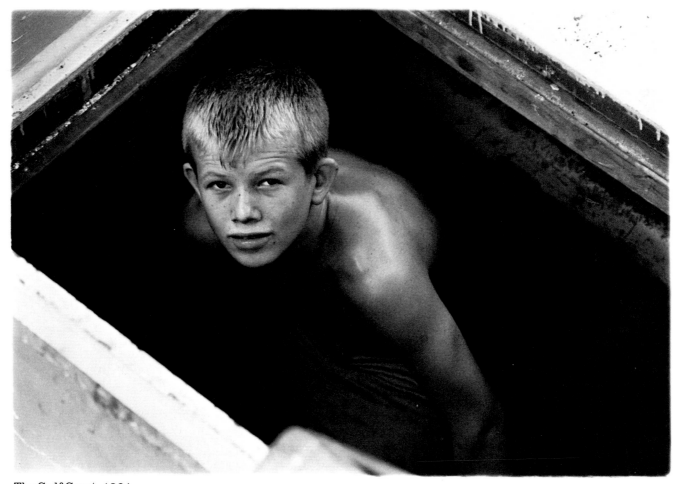

The Gulf Coast, 1964

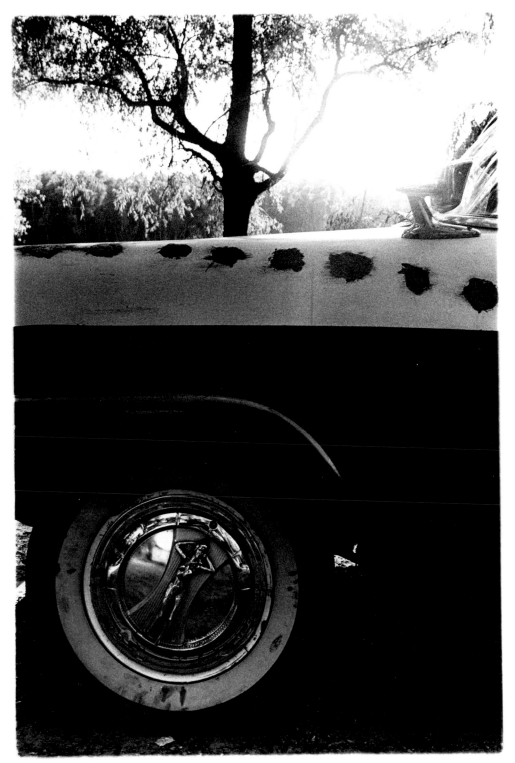

Mississippi, 1963

In the summer of 1962 my motorcycle broke down and, looking for something to do, I hitchhiked to Cairo, Illinois, where civil rights demonstrations had begun. It took about one demonstration and a speech by John Lewis, the Student Nonviolent Coordinating Committee's twenty-two-year-old chairman, to win me over to "the movement," the name everyone gave to the black revolt that was beginning to explode across the South. After that I went South every chance I got. Harry Belafonte put up $300 so that I could reach the Mississippi Delta and photograph Bob Moses and a group of SNCC workers who were registering voters. Taking shots at SNCC workers and brutally intimidating people attempting to vote was commonplace at the time, and it was impossible for me not to admire the courage of the people that I was meeting in the South. In June 1963 I went to Atlanta and, through the influence of the executive secretary, James Forman, became SNCC's first staff photographer.

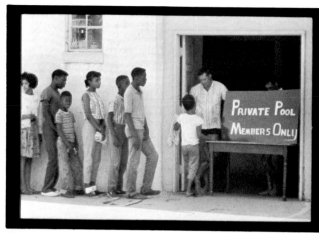 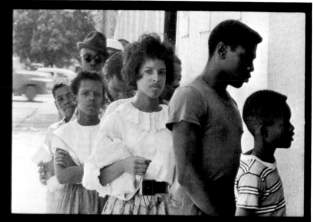

Cairo, Illinois, 1962

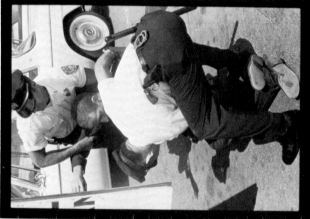 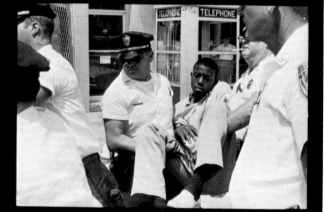

Albany, Georgia, 1962

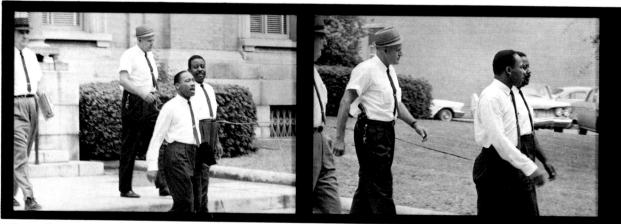

Albany, Georgia, 1962

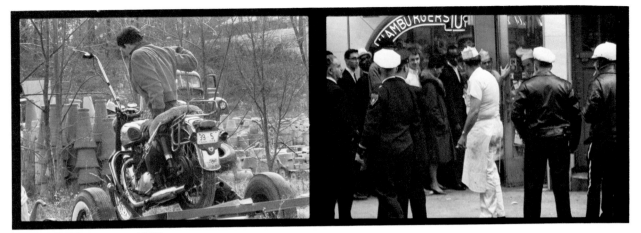

Nashville, Tennessee, 1962

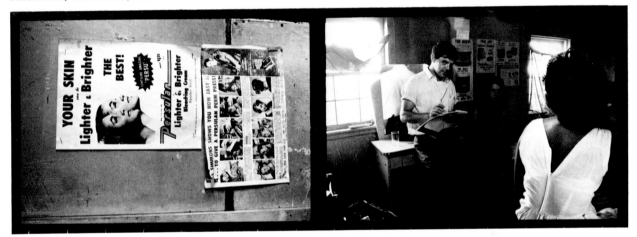

Terrell County, Georgia, 1963

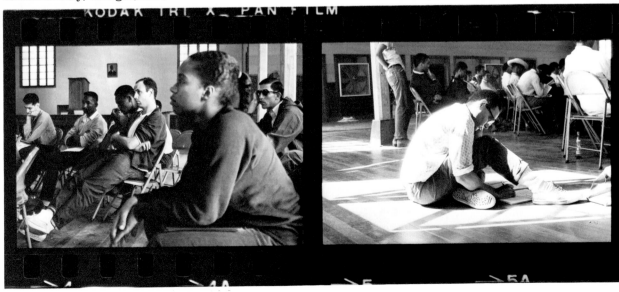

SNCC staff meeting, Waveland, Mississippi, 1964

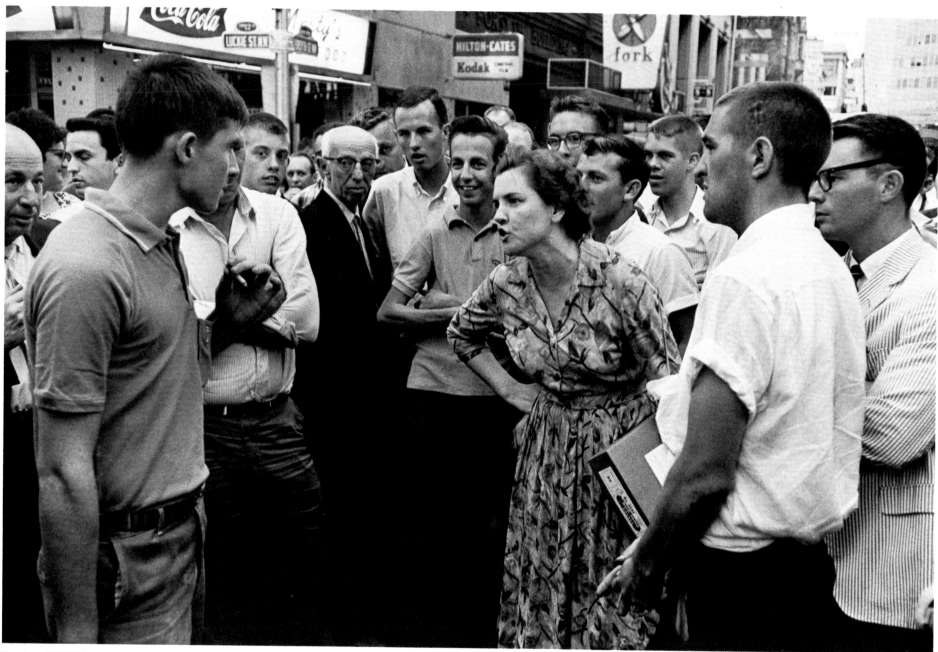

During SNCC demonstrations, Atlanta, 1963/64

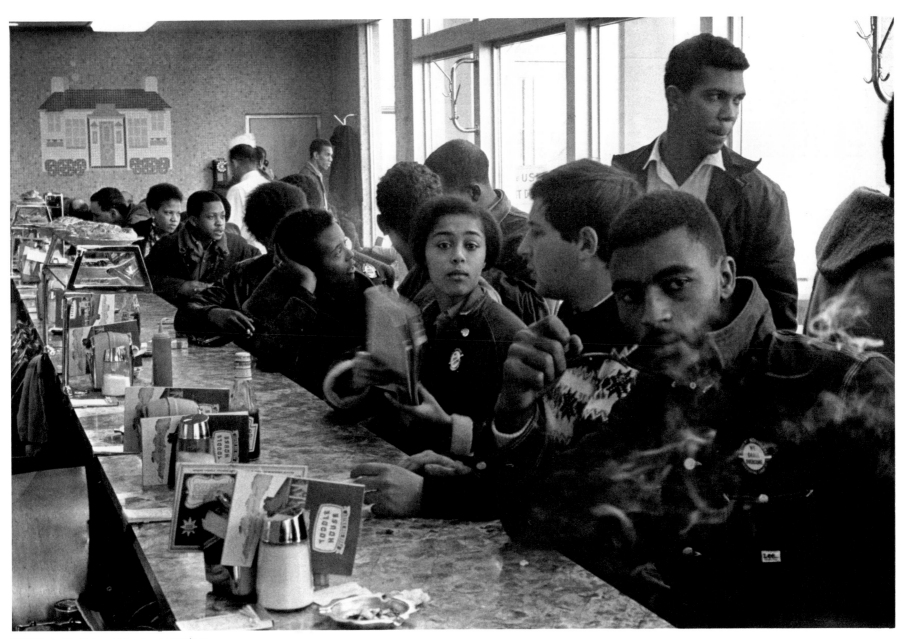

SNCC staff sit-in, Atlanta, 1963/64

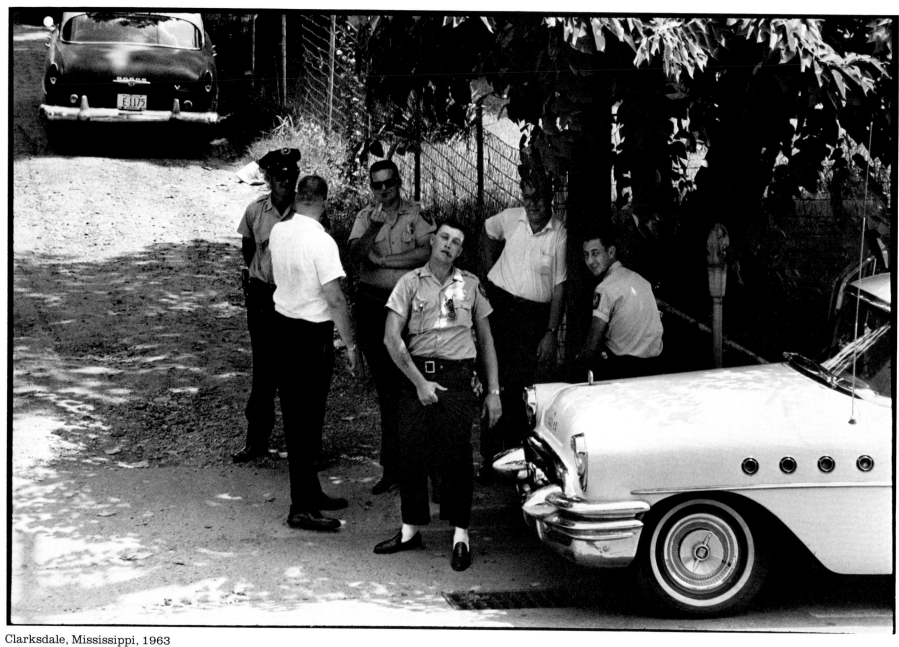

Clarksdale, Mississippi, 1963

18

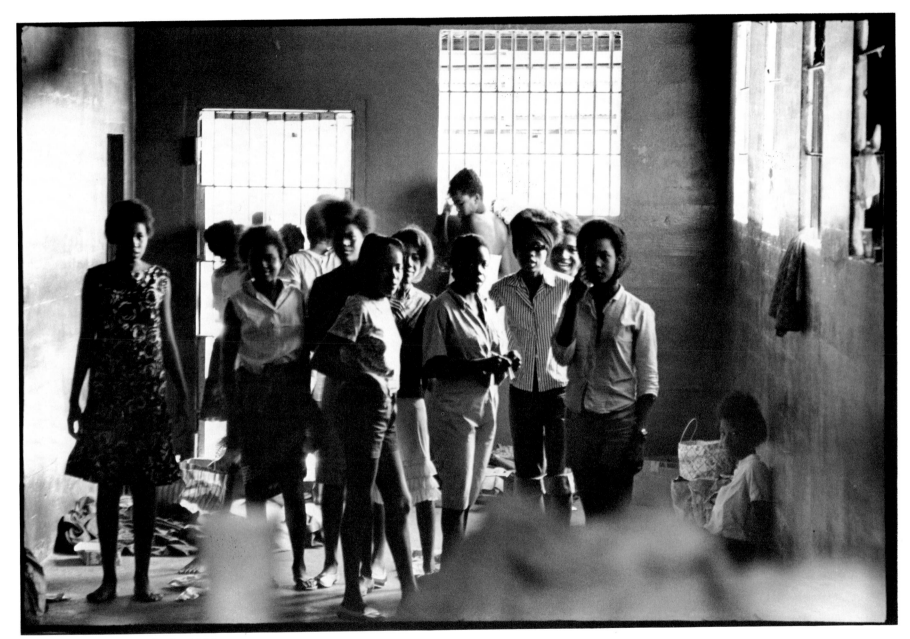

Leesburg, Georgia, stockade, 1963

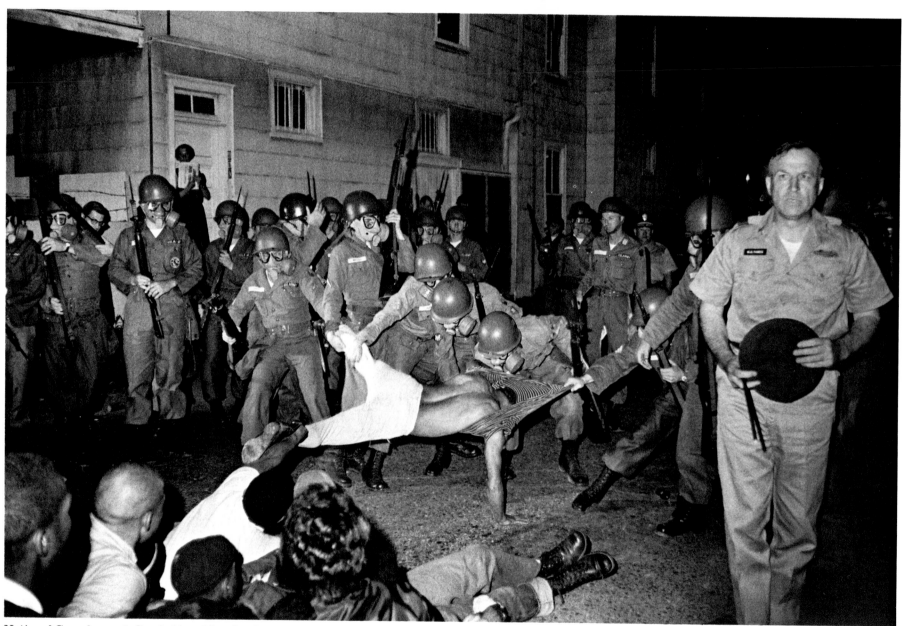

National Guard arrest, Cambridge, Maryland, 1964

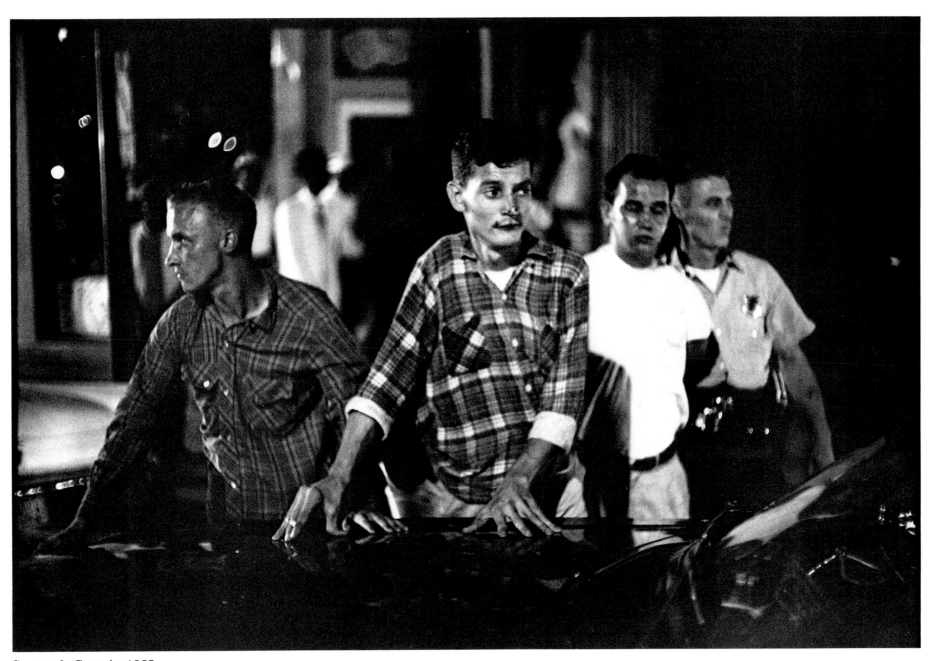

Savannah, Georgia, 1963

By January 1965 I was on my way back to New York City through Chicago. I remember reaching the city in a blizzard. My drive-away car had bald tires, a horned toad lizard in the glove compartment, and a trailer in tow that contained my darkroom and my Triumph motorcycle. I stayed in Chicago for more than two years and with a Rolleiflex lent to me by Hugh Edwards made pictures in Uptown, a north-side neighborhood of Southerners. I began making pictures of motorcyclists and joined the Chicago Outlaw Motorcycle Club with the intention of making a book about them, which I did, called *The Bikeriders*.

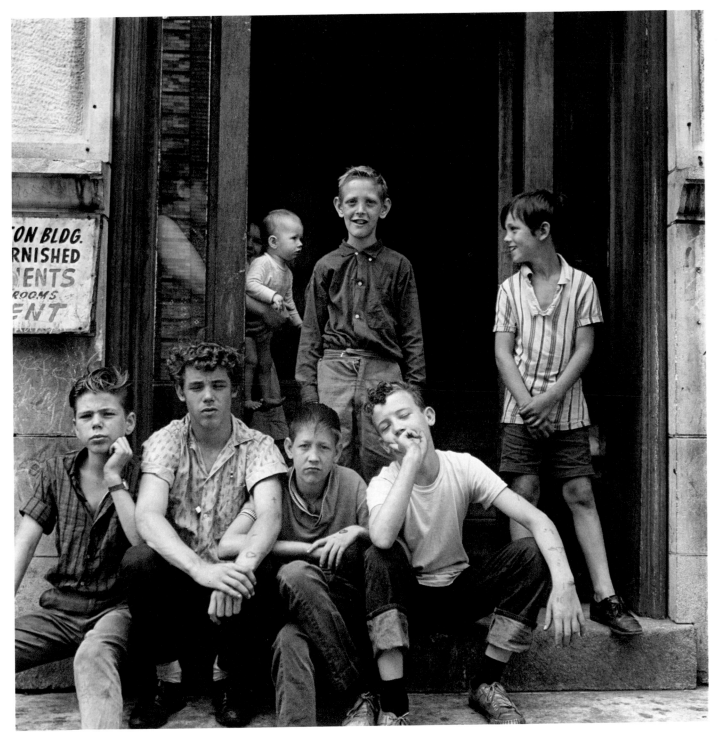

Uptown, Chicago, 1965

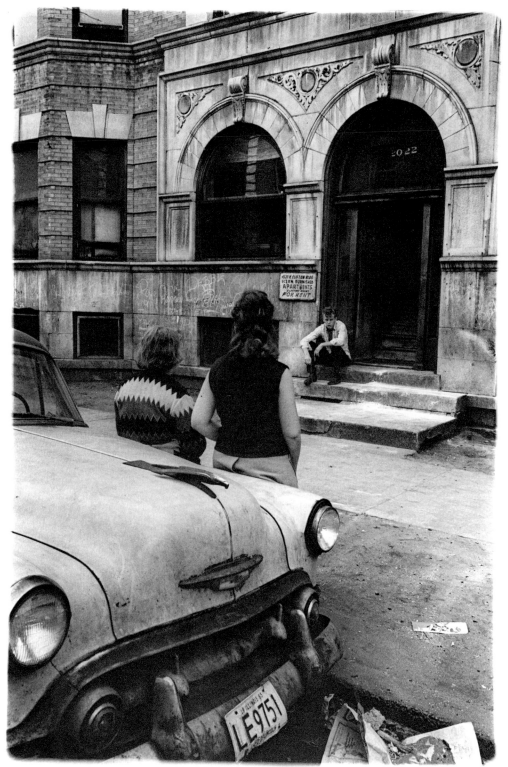

Uptown, Chicago, 1965

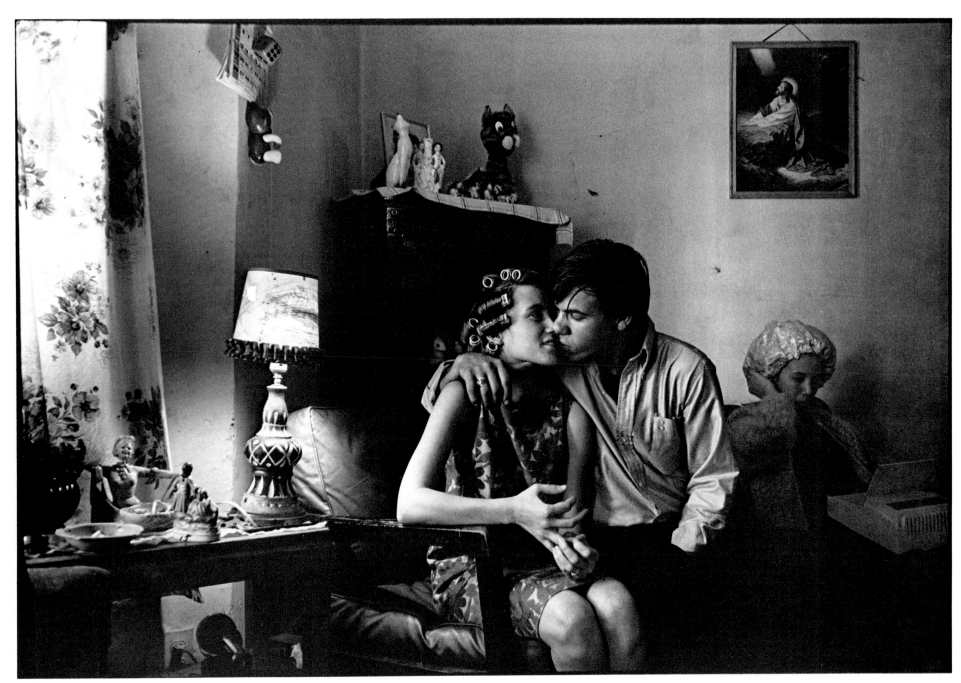

Uptown, Chicago, 1965

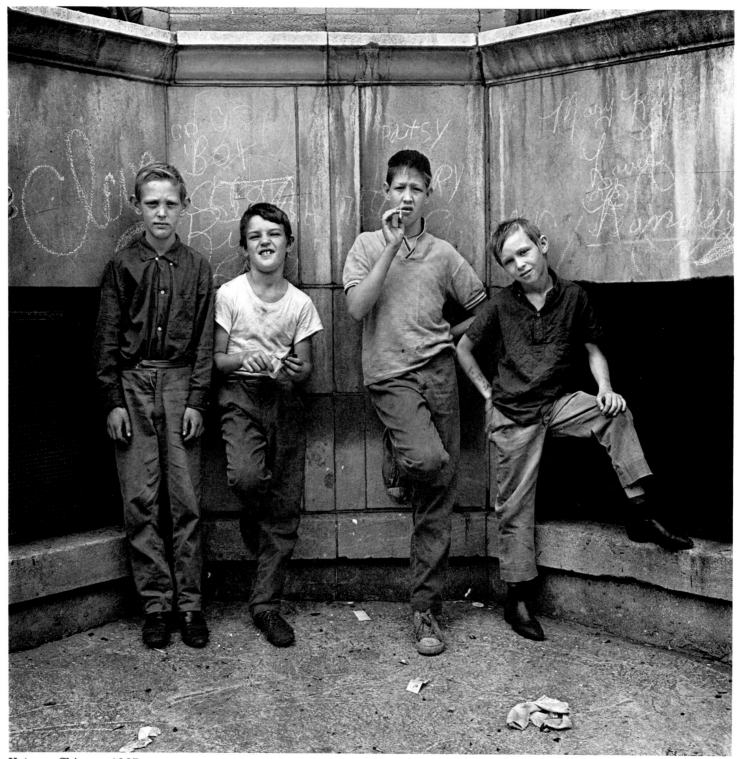

Uptown, Chicago, 1965

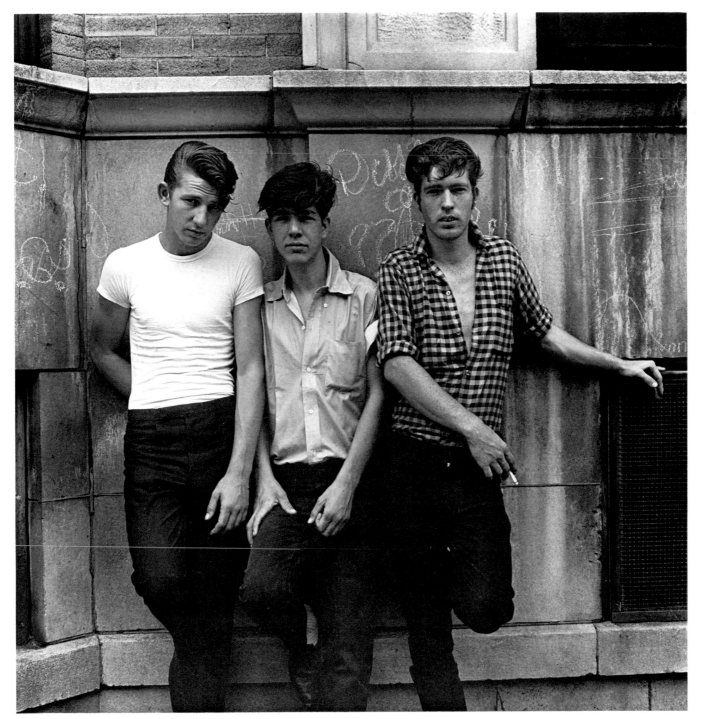

Uptown, Chicago, 1965

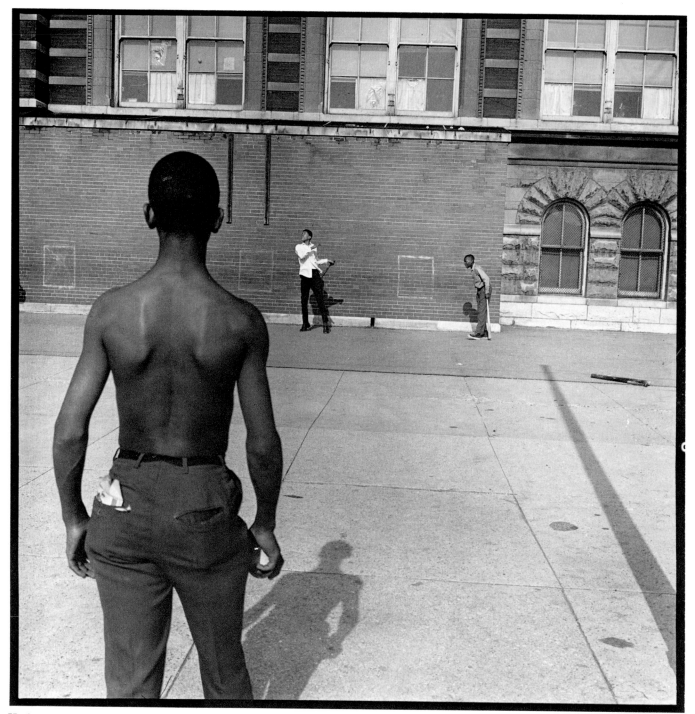

Hyde Park, Chicago, 1965

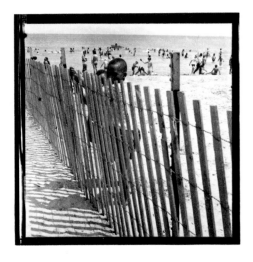
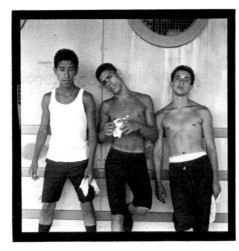
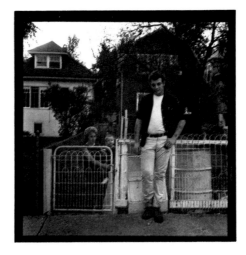
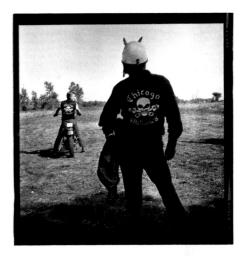
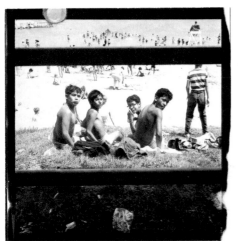
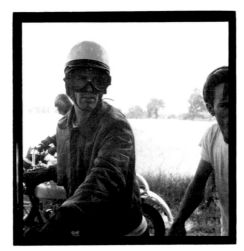
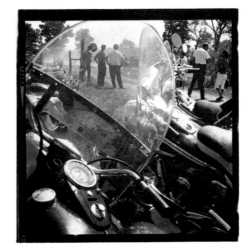
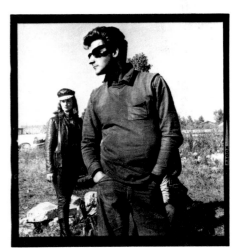

Chicago, 1965

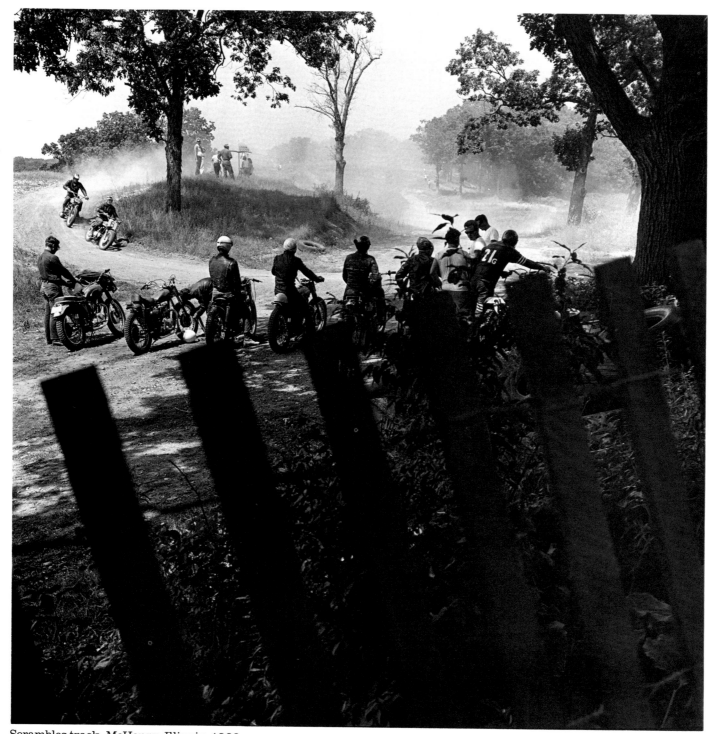

Scrambles track, McHenry, Illinois, 1966

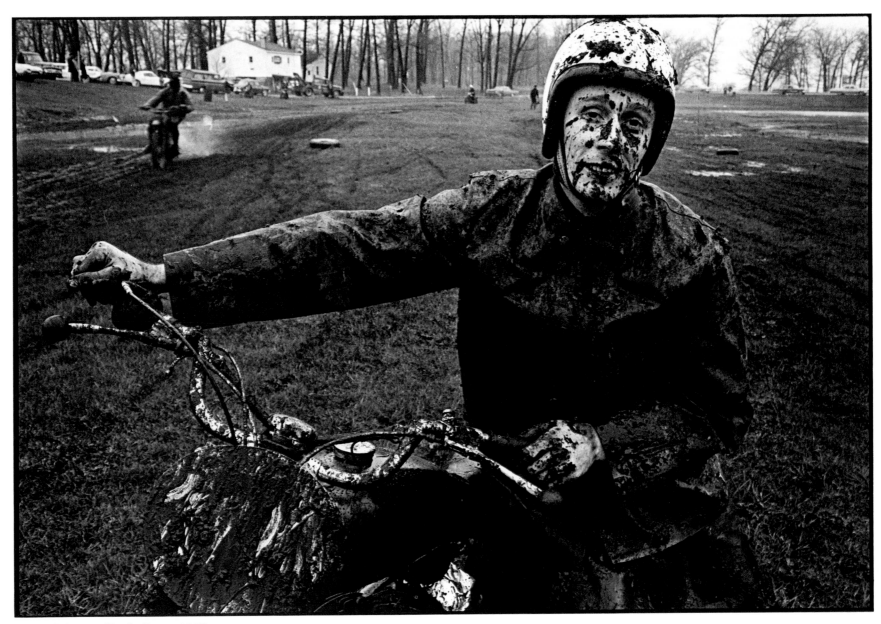

Racer, Schererville, Indiana, 1965

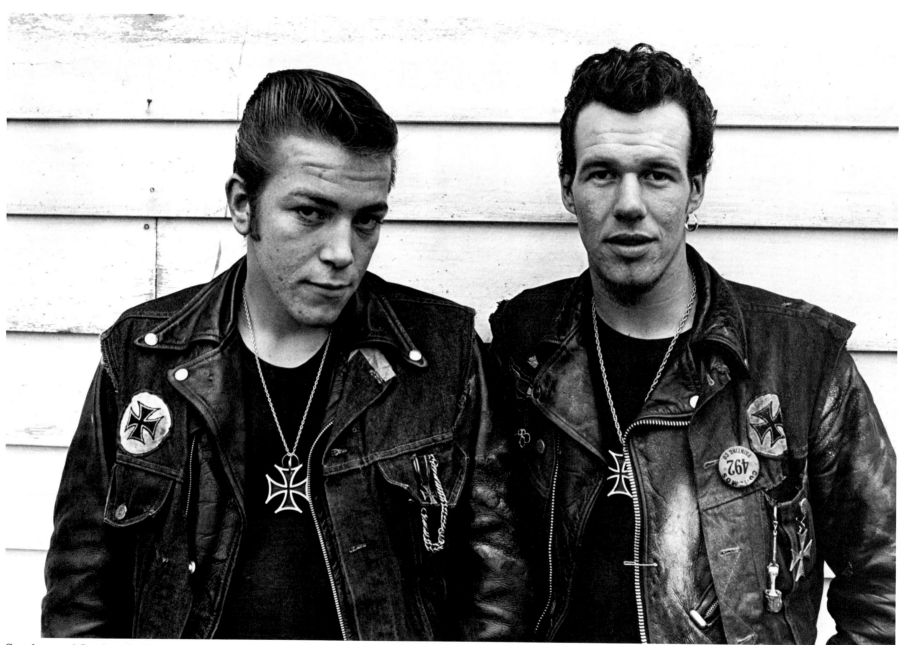

Sparkey and Cowboy, Indiana, 1965

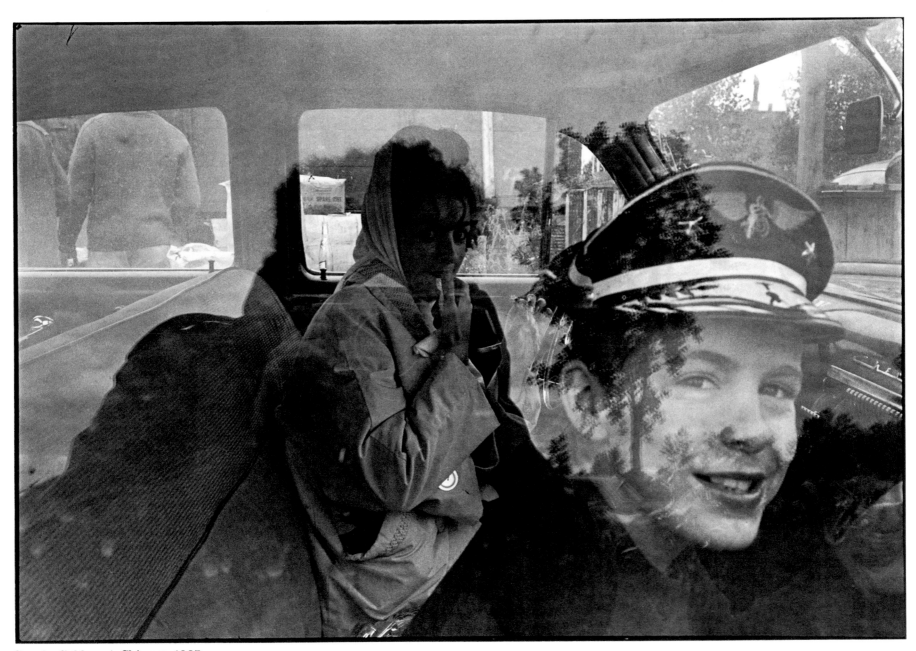

Gaucho field meet, Chicago, 1965

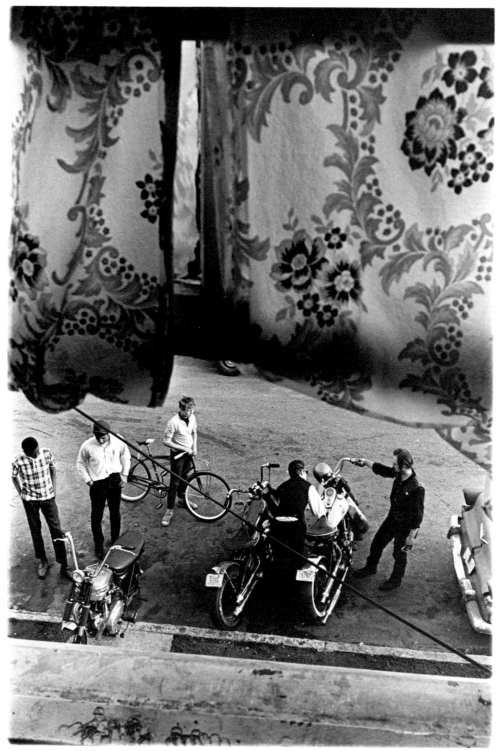

Louisville, Kentucky, 1966

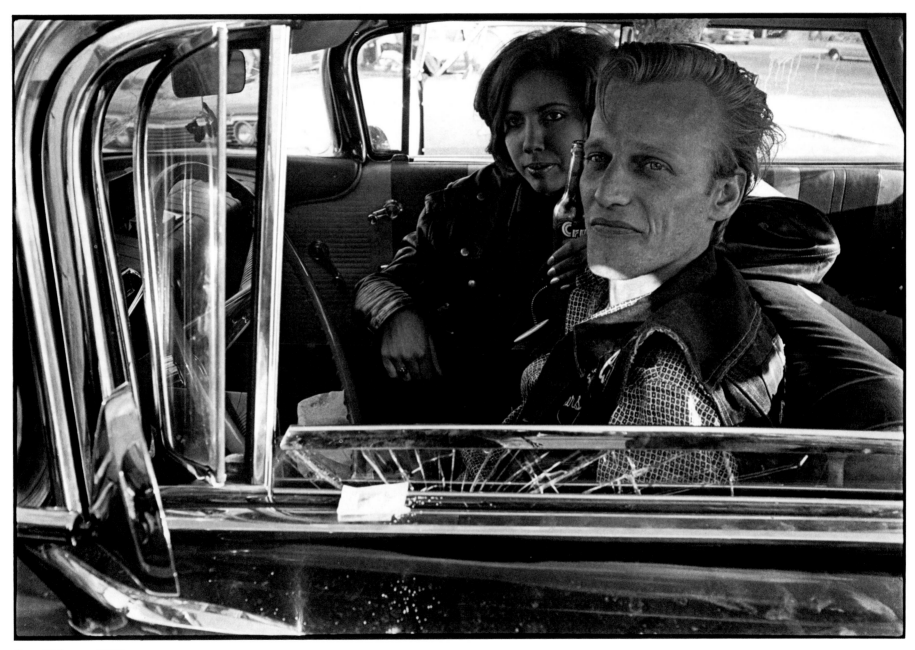

Joey, Chicago, 1966

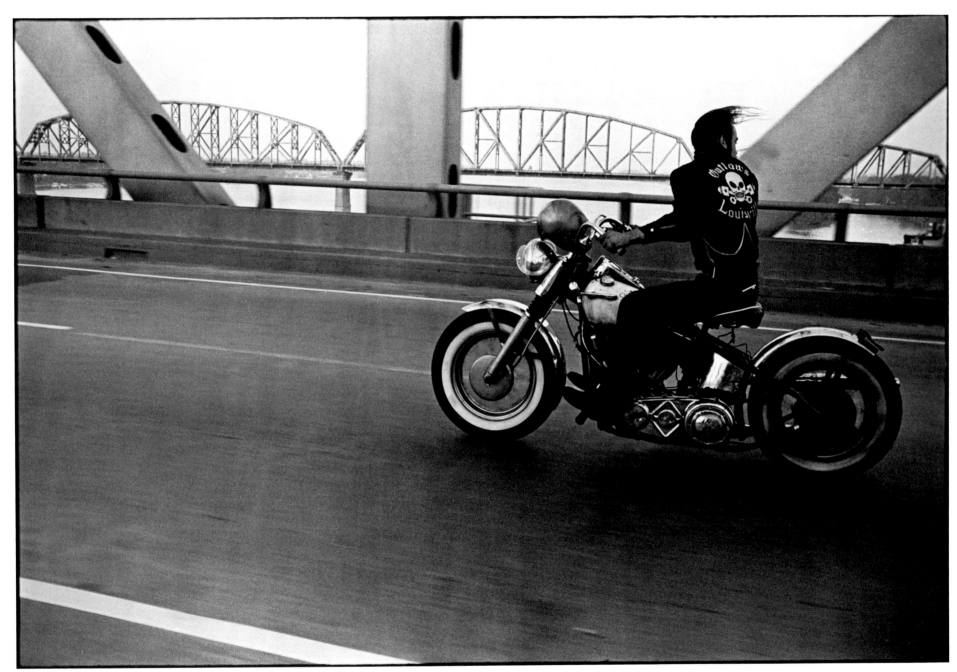

Crossing the Ohio River, Louisville, 1966

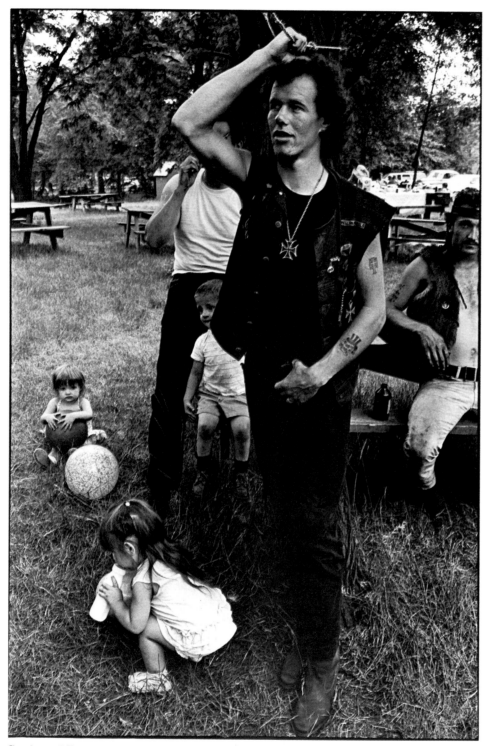

Cowboy at Rogues' picnic, Chicago, 1966

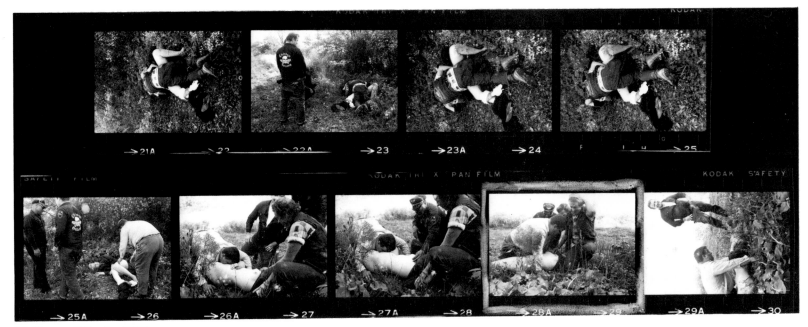

McHenry, Illinois, 1966

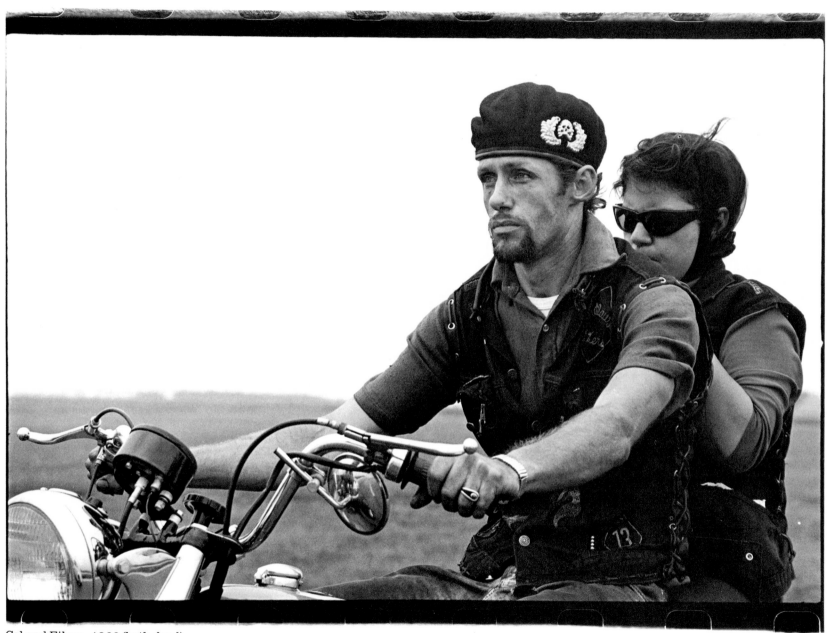

Cal and Eileen, 1966 (both dead)

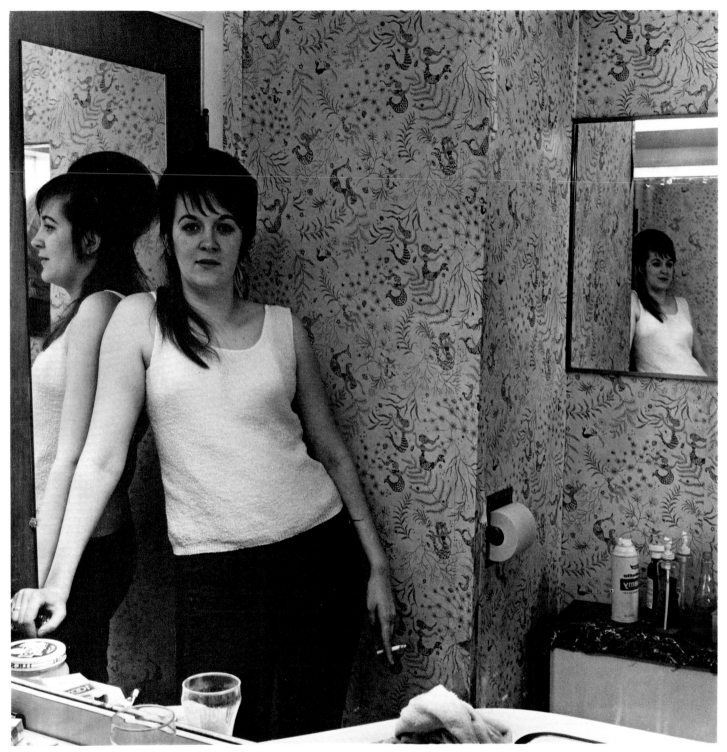

Kathy, Chicago, 1966

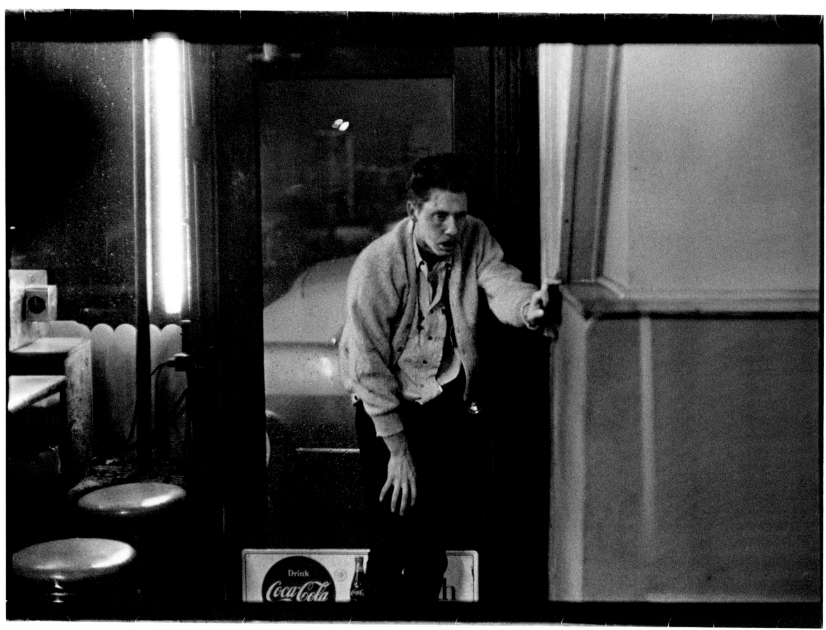

After being hit with a blackjack, Stoplight Café, Cicero, Illinois, 1966

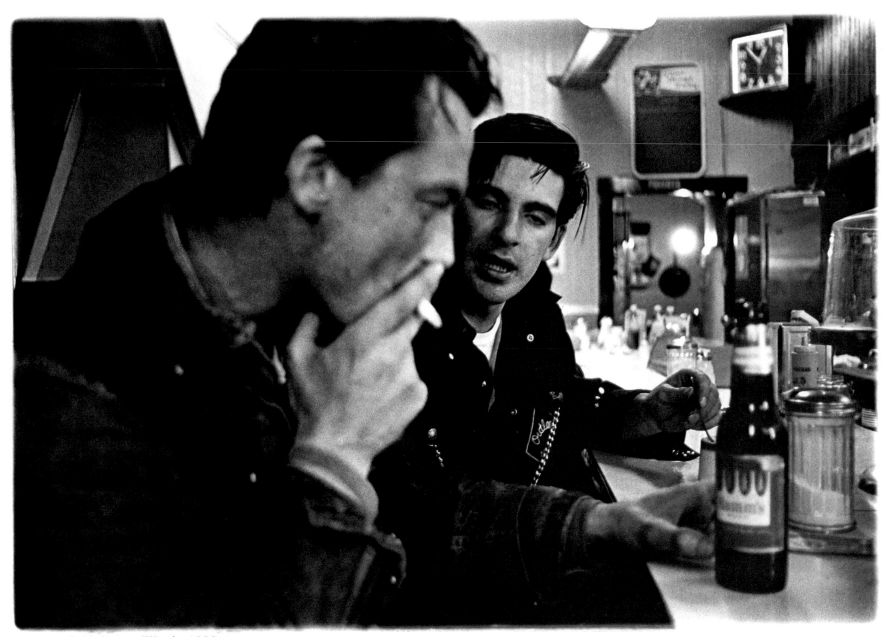

Stoplight Café, Cicero, Illinois, 1966

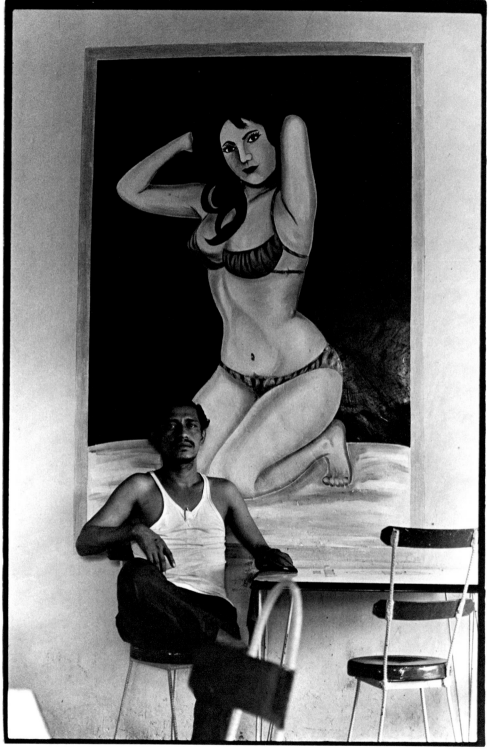

Hugh Edwards once told me, "Color pictures are what you get when you put color film in the camera." Late in 1965 I started doing just that. I spent New Year's Eve riding the subway in New York with my camera on a tripod.

Mérida, Yucatán, Mexico, 1968

NIPPON CHROMART LAB.

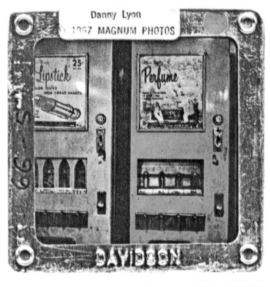

Danny Lyon
© 1967 MAGNUM PHOTOS

DAVIDSON

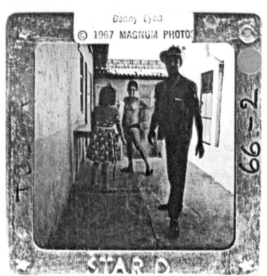

Danny Lyon
© 1967 MAGNUM PHOTOS

STARD

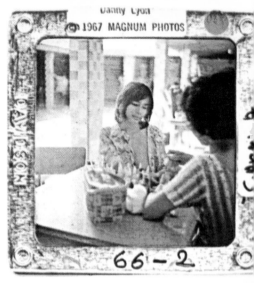

Danny Lyon
© 1967 MAGNUM PHOTOS

66-2

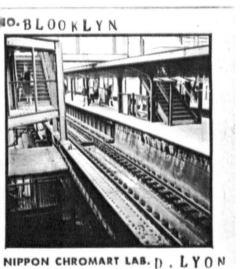

NO.BLOOKLYN

NIPPON CHROMART LAB. D.LYON

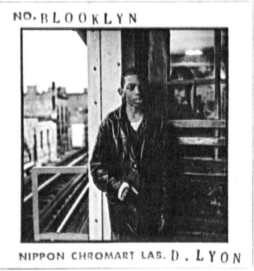

NO.BLOOKLYN

NIPPON CHROMART LAB. D.LYON

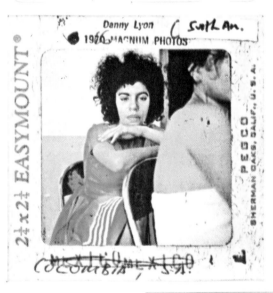

Danny Lyon
1967 MAGNUM PHOTOS

2¼ x 2¼ EASYMOUNT

PEGCO
SHERMAN OAKS, CALIF., U.S.A.

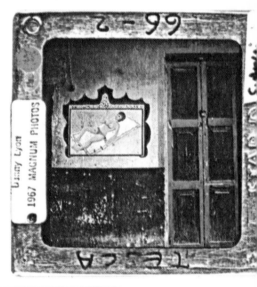

Danny Lyon
1967 MAGNUM PHOTOS

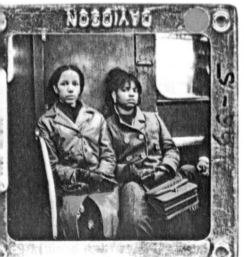

DAVIDSON

Danny Lyon
© 1967 MAGNUM PHOTOS

FULTON
ST

DAVIDSON

DAVIDSON

In 1966 an American could get a round-trip ticket from Miami to the Colombian coast for $125. He could explore almost any barrio with impunity and buy a big bagful of marijuana for a couple of bucks. A friend of mine, Shirley Fischer, a Ph.D. candidate at the University of Chicago, went to Cartagena and I invited myself along. That same year Camillo Torres, a one-time graduate student at the University of Minnesota and a popular priest from Bogotá, was killed in his first engagement as a guerrilla against the Colombian Army. Naïvely I had stepped onto a continent that was being torn apart by its own contradictions.

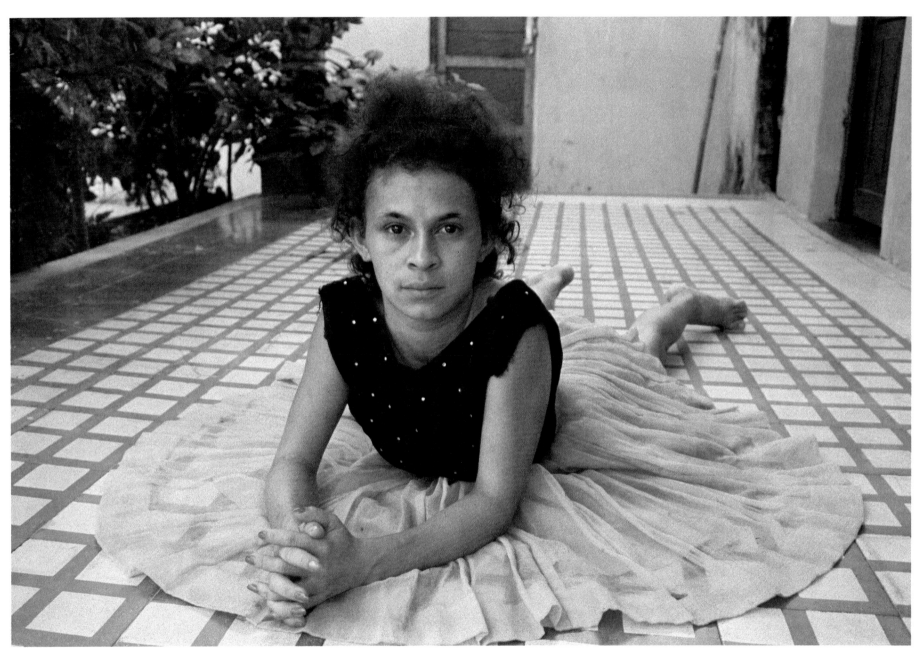

Carmen, Cartagena, Colombia, 1966

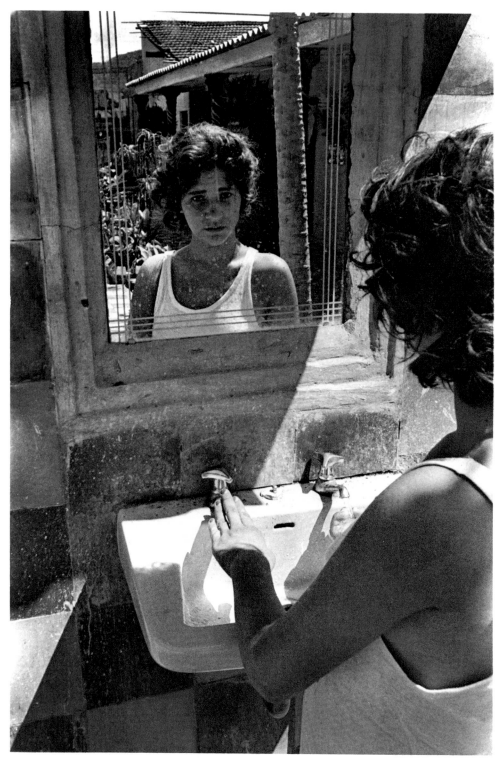

Maria, Cartagena, 1966

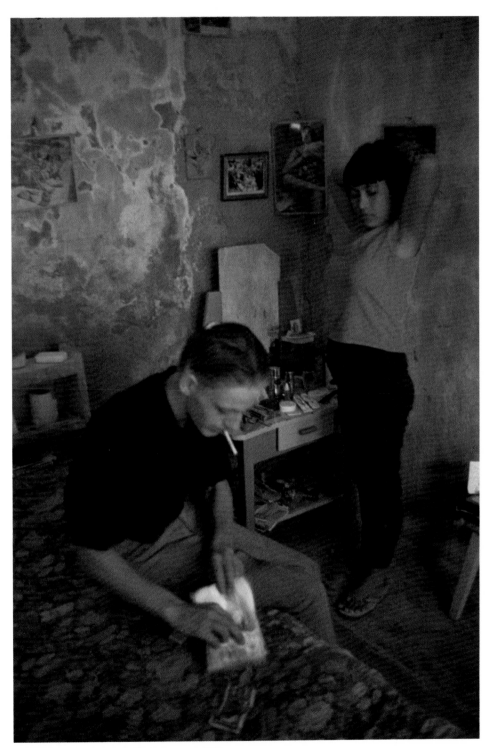

Peter and girlfriend, Cartagena, 1966

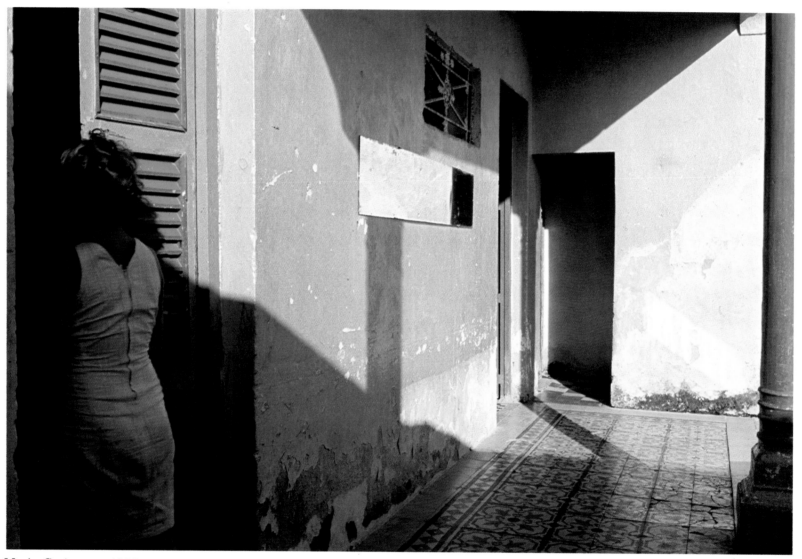

Maria, Cartagena, 1966

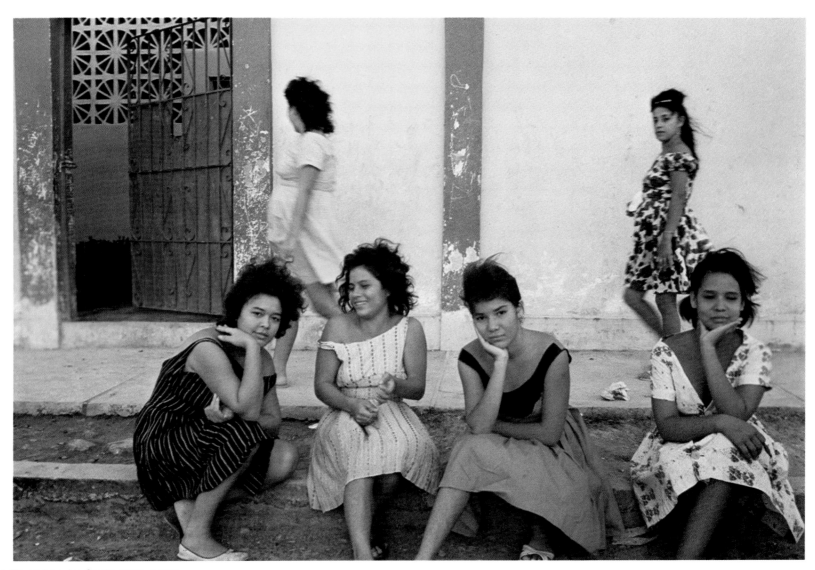

Tesca barrio, Cartagena, 1966

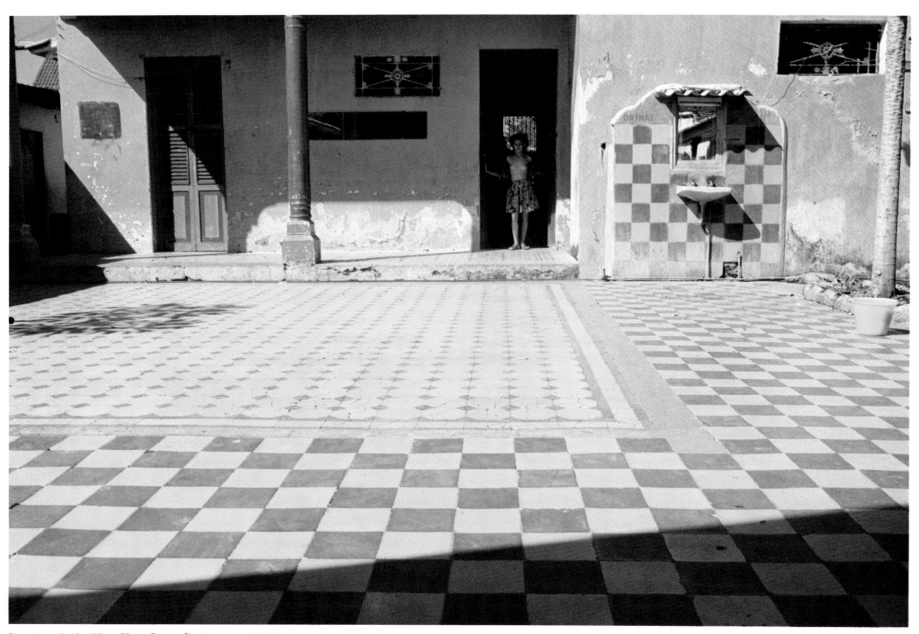

Courtyard, the New Vera Cruz, Cartagena, 1966

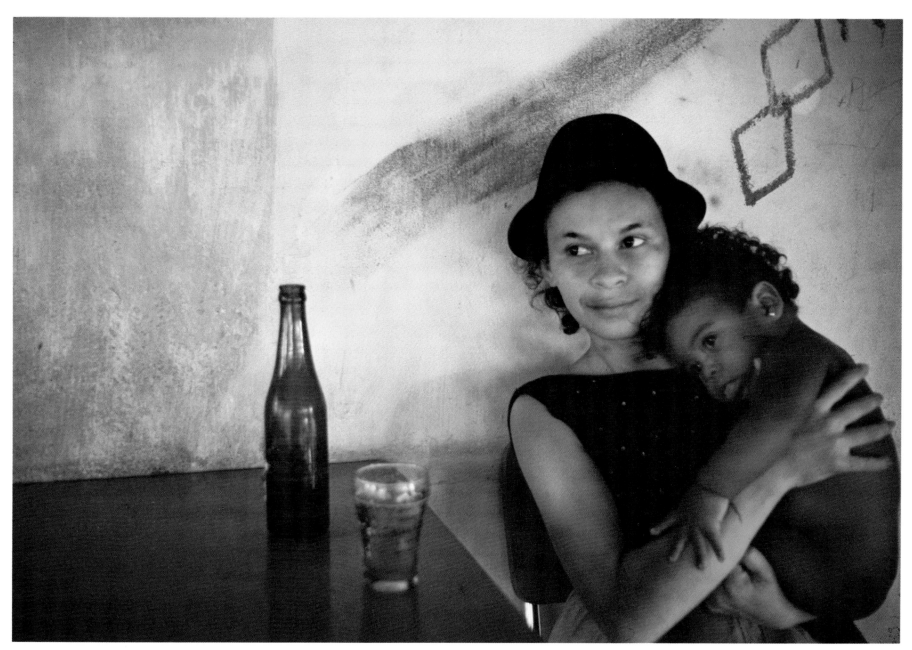

Carmen and daughter, Cartagena, 1966

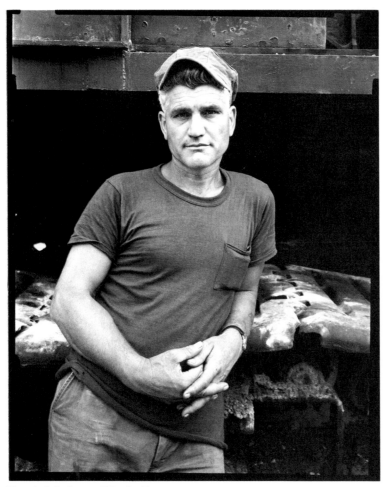

Dominick, lower Manhattan, 1967

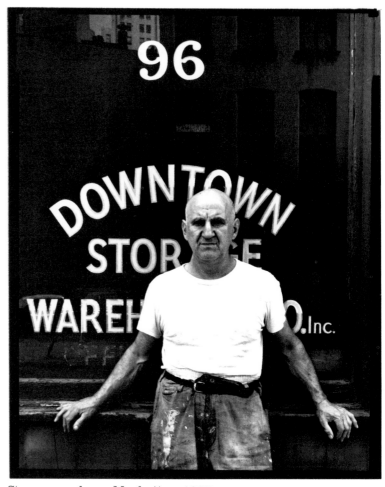

Store owner, lower Manhattan, 1967

The Outlaws held their 1966 New Year's Eve party in a Milwaukee tavern, and Zipco, one of the members of the Milwaukee Outlaws, suggested that the boys tip over the bar and burn the place down. He called it "an end of an era." It was my last party with the Outlaws. In January 1967 I finally reached New York and rented a small loft at the corner of Beekman and Williams Streets in Lower Manhattan. The buildings all around mine, among the oldest in New York, were being demolished. That year eighty acres of buildings were destroyed on the East and West Sides of Manhattan below Canal Street.

When Dominick, the demolition-crew foreman, first saw me, he asked why I had a camera over my shoulder and not a gun. The war was heating up in Southeast Asia. I remember seeing it glorified in *Look* magazine, although as early as 1965 one of the women in SNCC was circulating pictures of atrocities committed by American soldiers. Dominick, whose brother had died in his arms at Tarawa in World War II, told me that if I came near one of his buildings he'd "drop a wall on me." Later we became good friends.

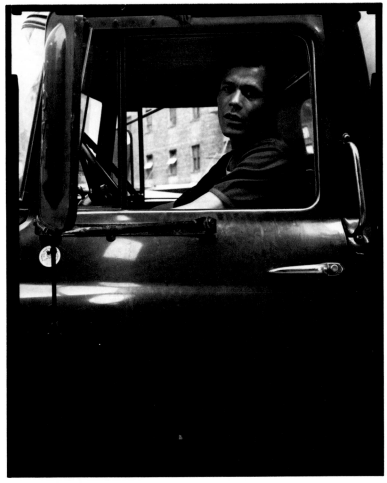

Lower Manhattan, 1967

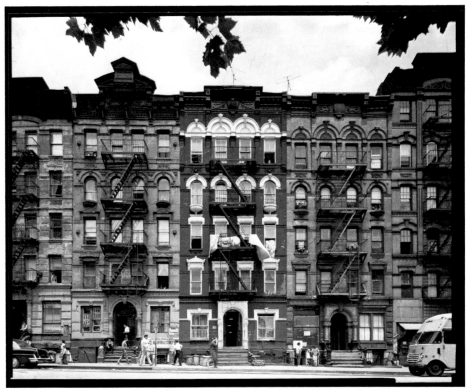

Madison Street, Lower East Side, 1967

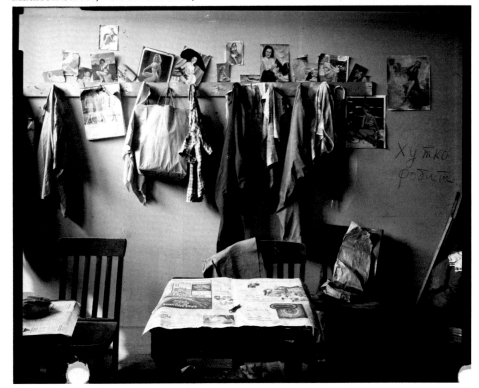

Demolition crew's room, lower Manhattan, 1967

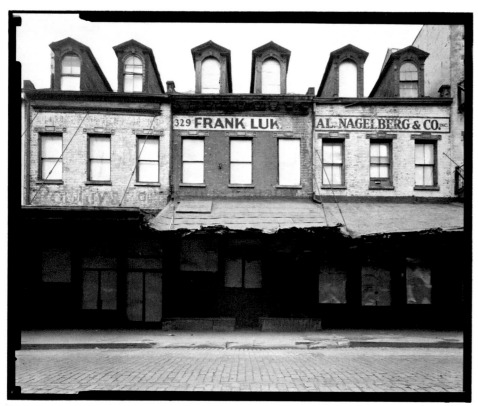

Washington Street, 1967

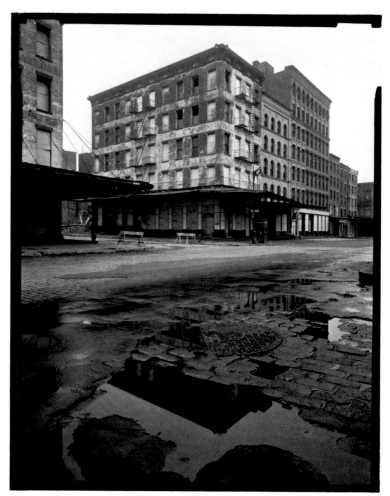

West Street at Jay, 1967

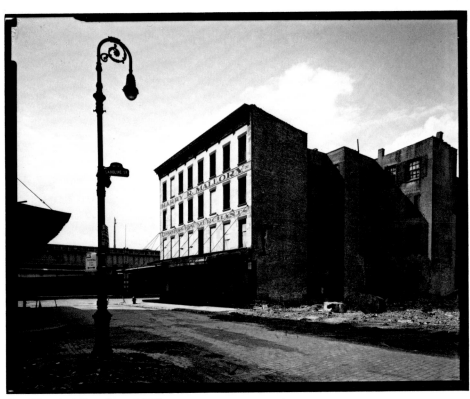

Jay Street at Caroline, 1967

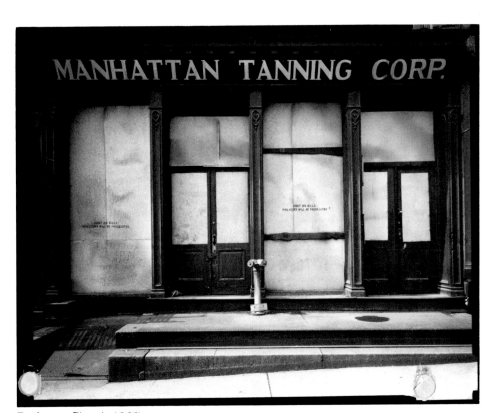

Beekman Street, 1967

As I sat in my Beekman Street loft watching the neighborhood being smashed into brick dust, the war in Vietnam began to rage. America, the America that I believed in anyway, was standing on her head. If I was going to find a subject that had meaning for me, I was going to have to find it at the bottom of society, not at the top. I began to think about working inside a prison. Then I left for Knoxville, Tennessee, the birthplace of James Agee, searching for something I would not find until I reached Texas.

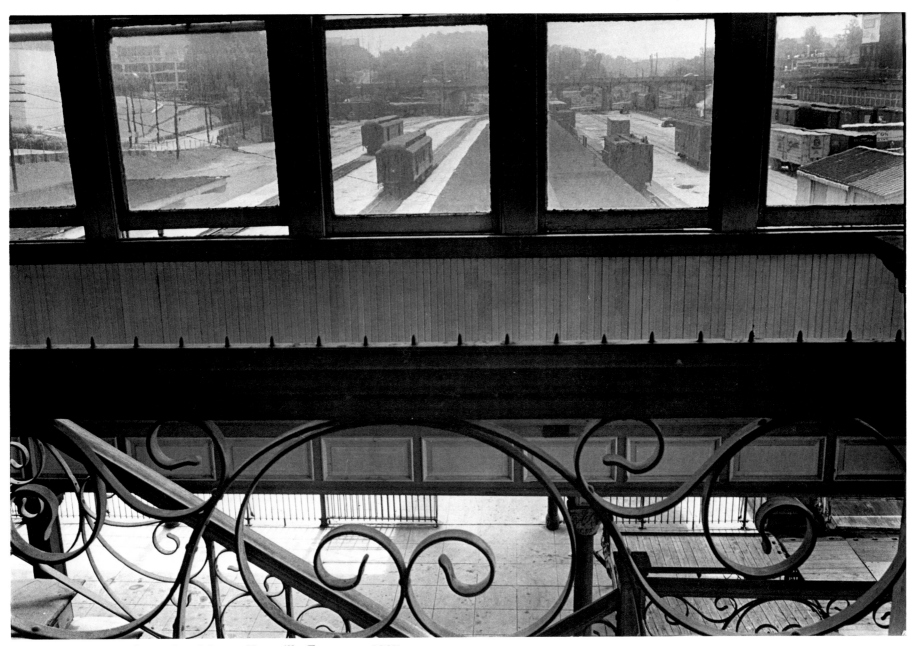

Railroad station near James Agee's home, Knoxville, Tennessee, 1967

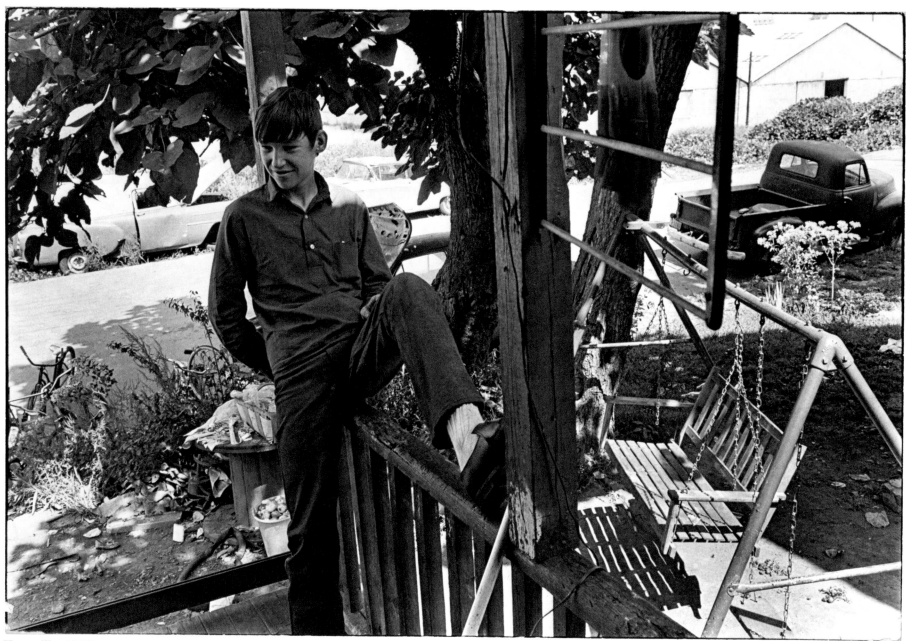

Knoxville, 1967

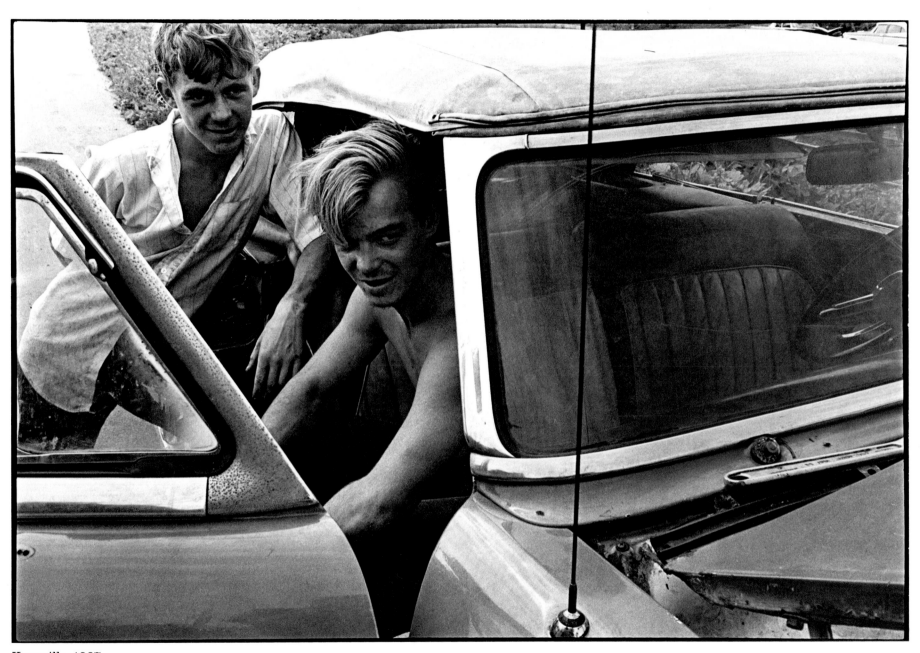

Knoxville, 1967

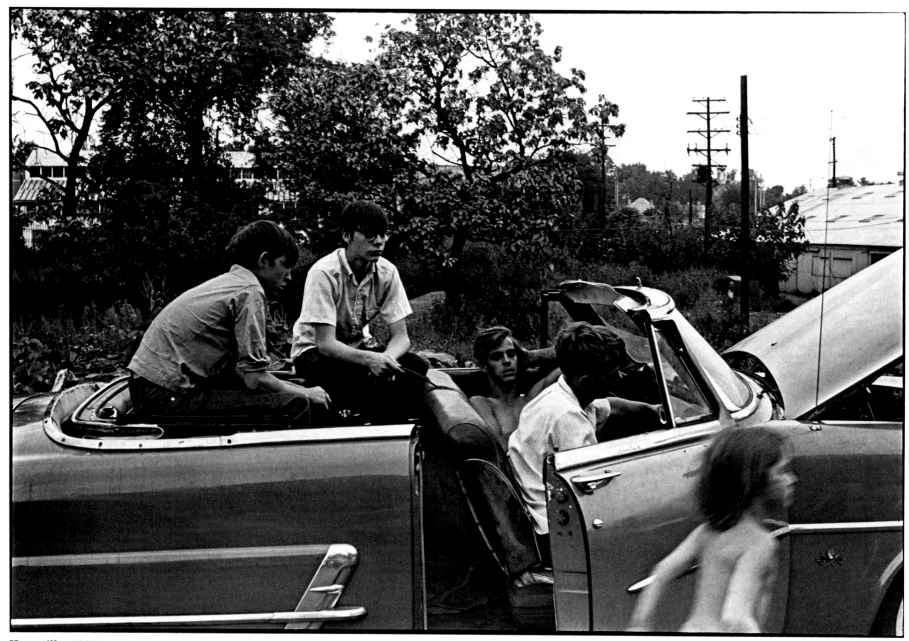

Knoxville, 1967

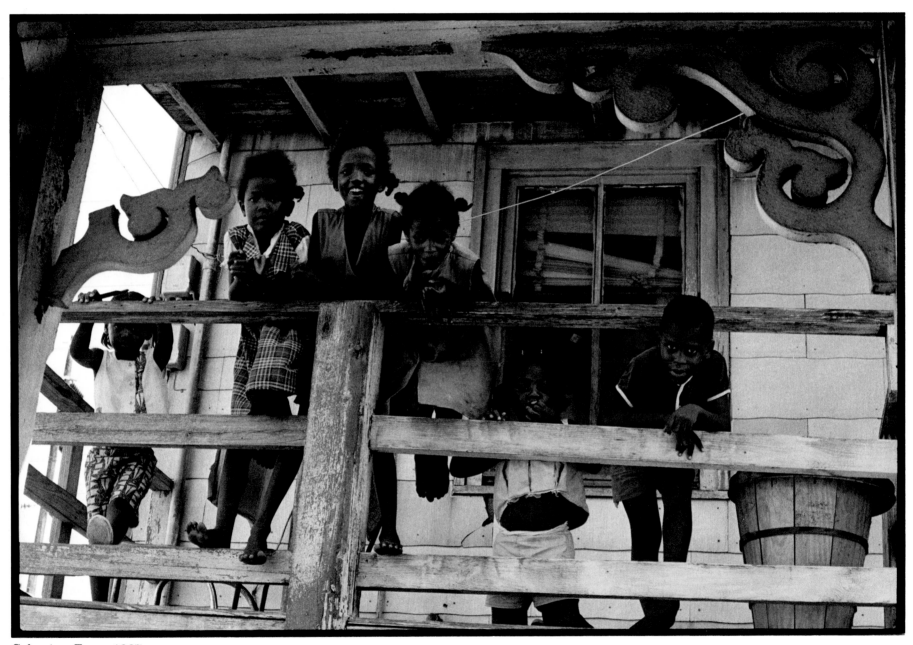

Galveston, Texas, 1967

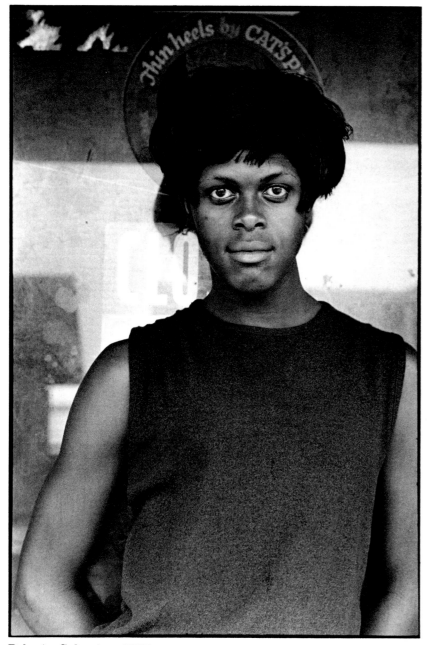

Roberta, Galveston, 1967

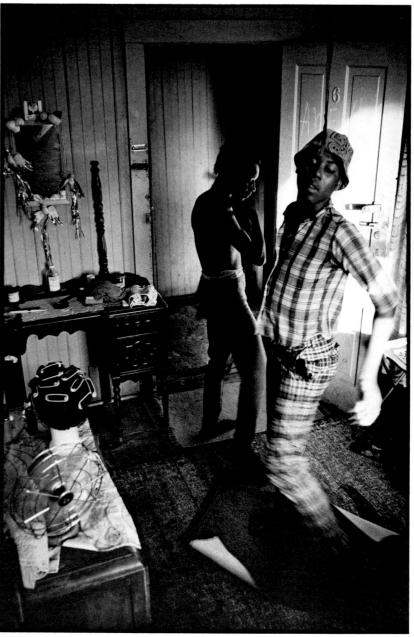

Pumpkin René, Galveston, 1967

Zipco once talked to me about shrimp boats in Galveston. When I got there I hung out with some black transvestites. Then one day I saw a poster inviting the public to the Huntsville Prison rodeo "every Sunday in October." I had found what I was looking for and in some ways my feelings about myself and about America have never been the same.

66

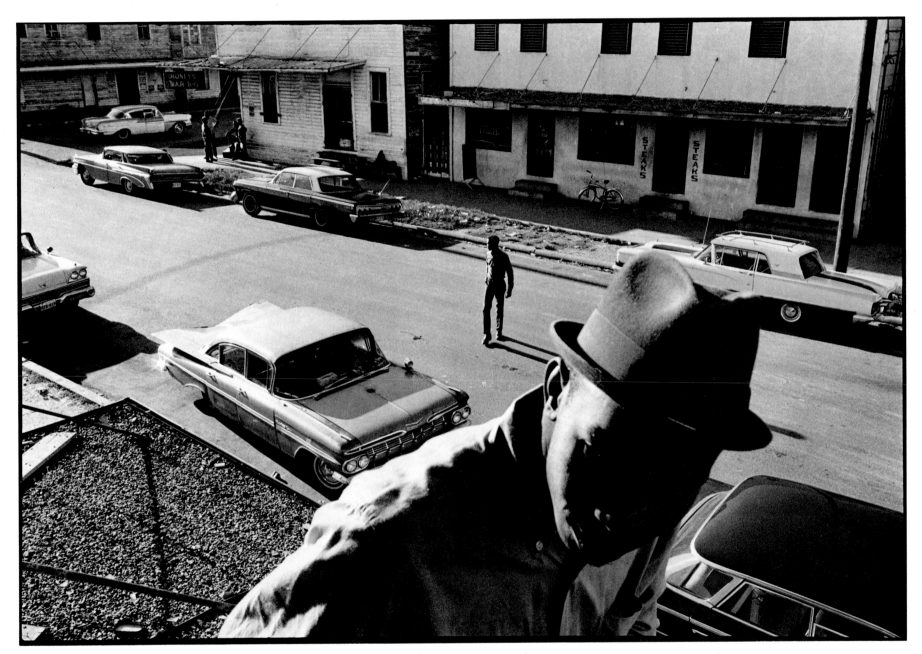

Galveston, 1967

In December 1967 Dr. George Beto, director of the Texas Department of Corrections, gave me permission to photograph every part of the T.D.C. with the exception of death row and the electric chair. Even so, one of the guards soon led me to the chair, affectionately called "Old Sparky," and offered to take my picture if I'd sit in it. In 1971 I published a book of my pictures, *Conversations with the Dead*, that I hoped would strike a blow at all our prisons. That same month New York's governor, Nelson Rockefeller, ordered the attack on rebellious Attica, killing forty men.

Years later, in the 1970s, a Chicano inmate sued the Texas Department of Corrections, and the United States Department of Justice came into the case on behalf of the inmates. *Ruiz* v. *Estelle* (then the new director of the T.D.C.) became the longest trial in the history of the Department of Justice. I was asked to be a witness on behalf of the inmates so that my pictures, made ten years earlier, could be introduced as evidence in a trial record that was expected to reach the Supreme Court. Ironically, Bruce Jackson, a writer and film maker who had been instrumental in getting me inside the T.D.C. in the first place, appeared as a witness for the prison. In a classic debate over the treatment of men in the Twentieth Century, each side was ready with its artist-in-residence.

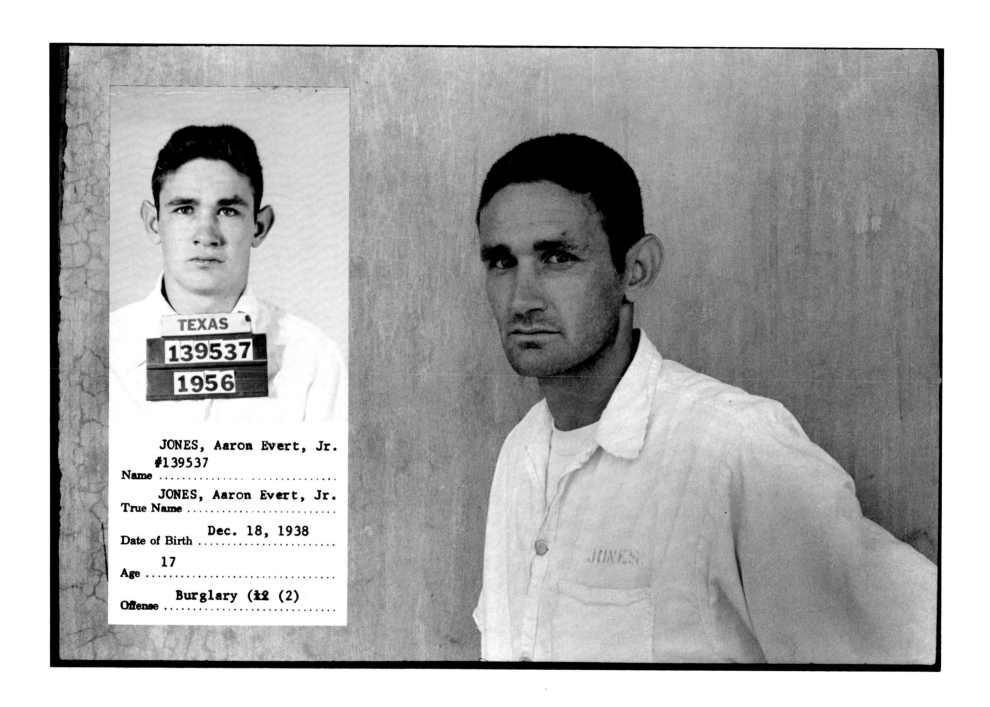

Aaron Evert Jones. Shot and killed in Dallas. November 1979. This is his memorial.

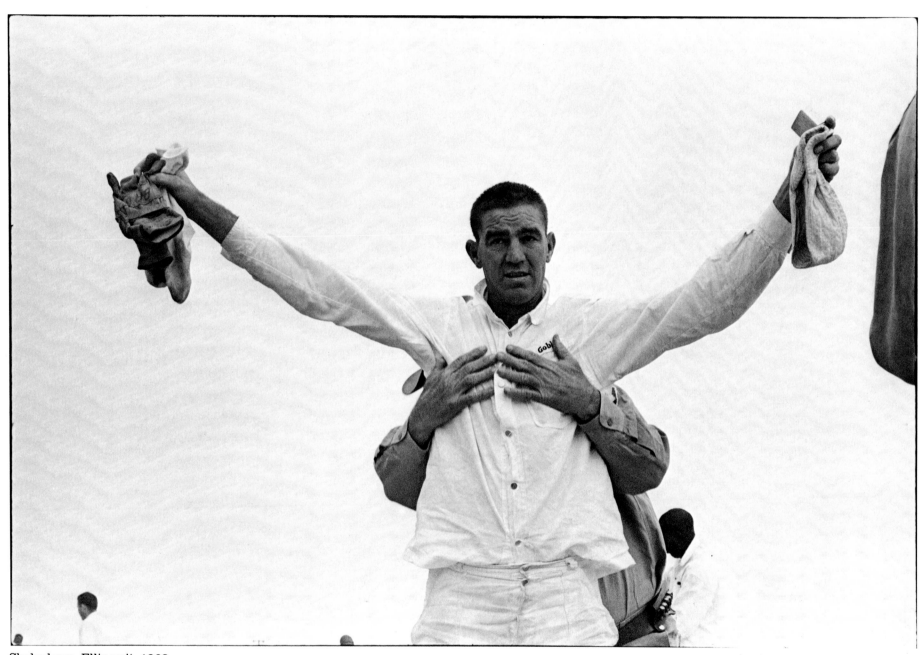

Shakedown, Ellis unit, 1968

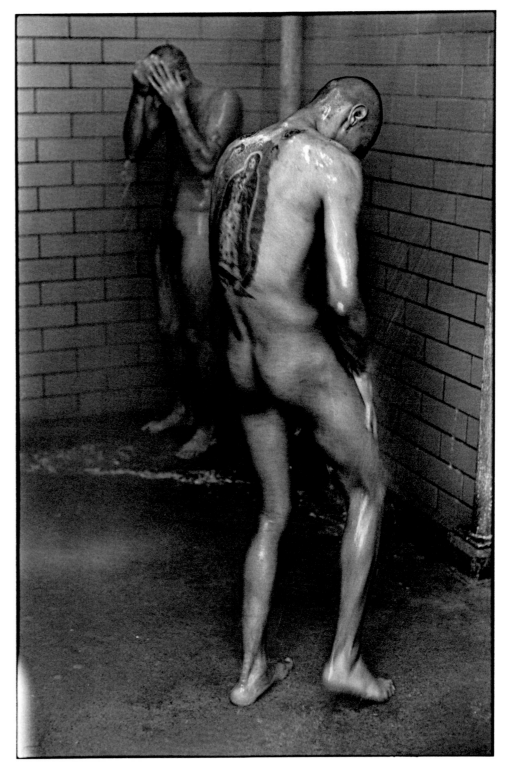

New arrivals, Diagnostic unit, 1967

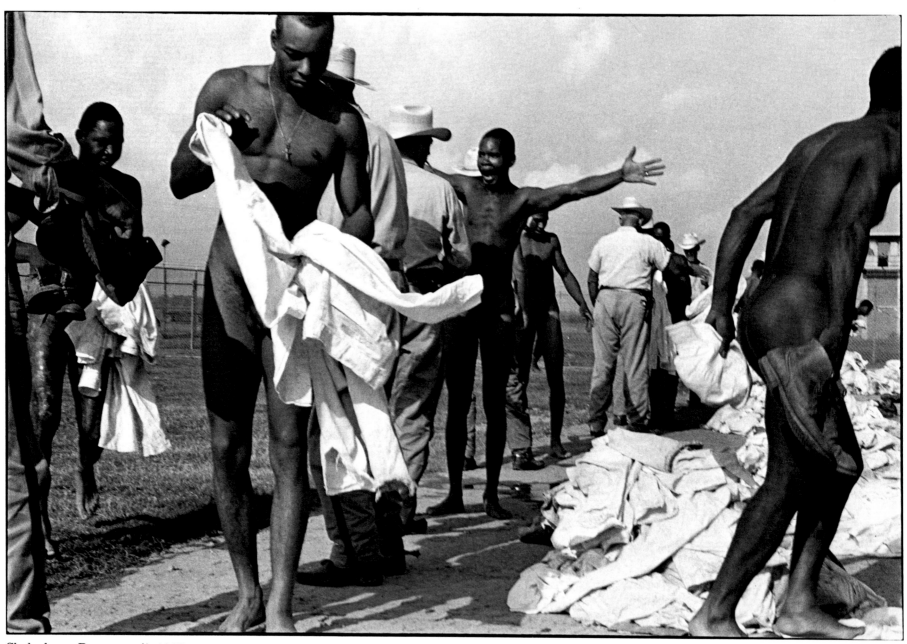

Shakedown, Ramsey unit, 1968

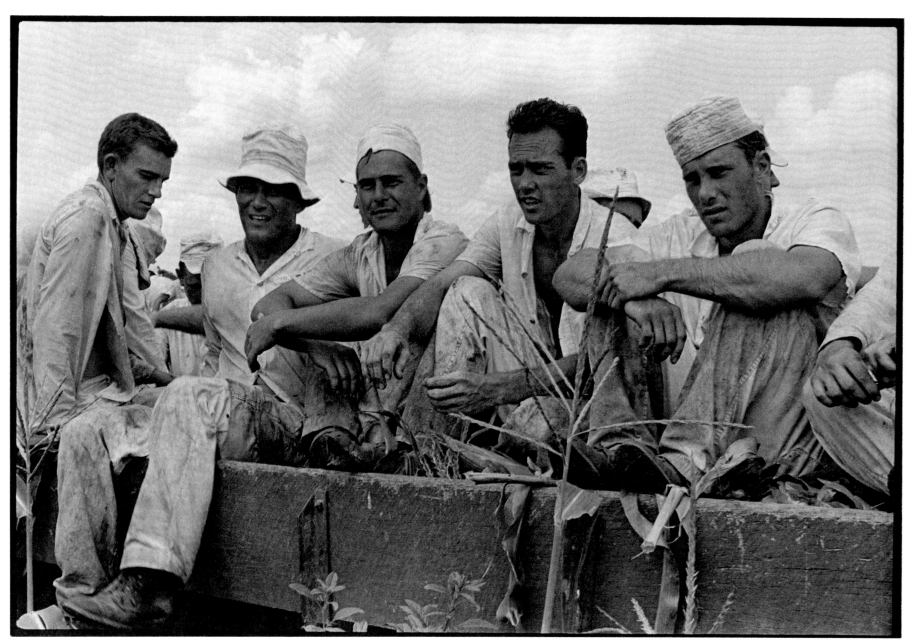

Corn wagon, Ramsey unit, 1968

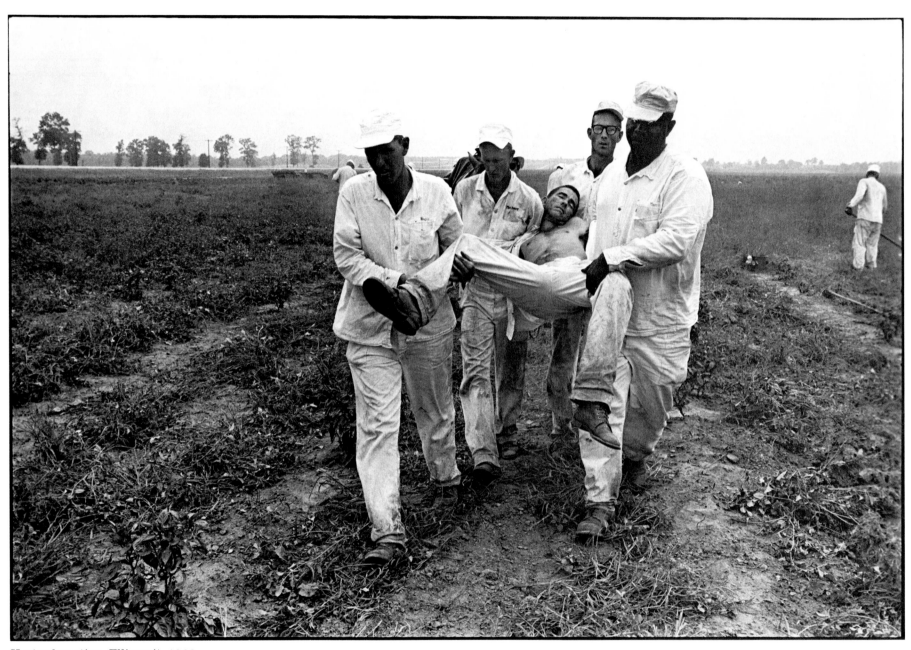

Heat exhaustion, Ellis unit, 1968

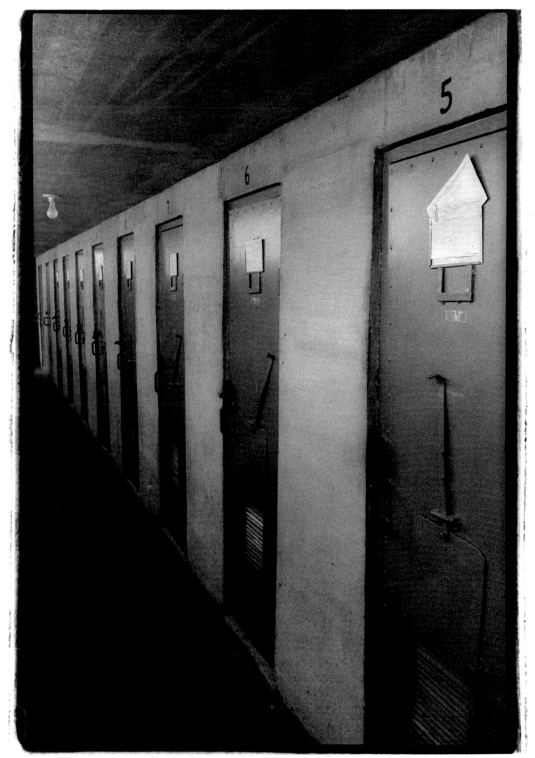

Solitary Confinement, Ramsey unit, 1968

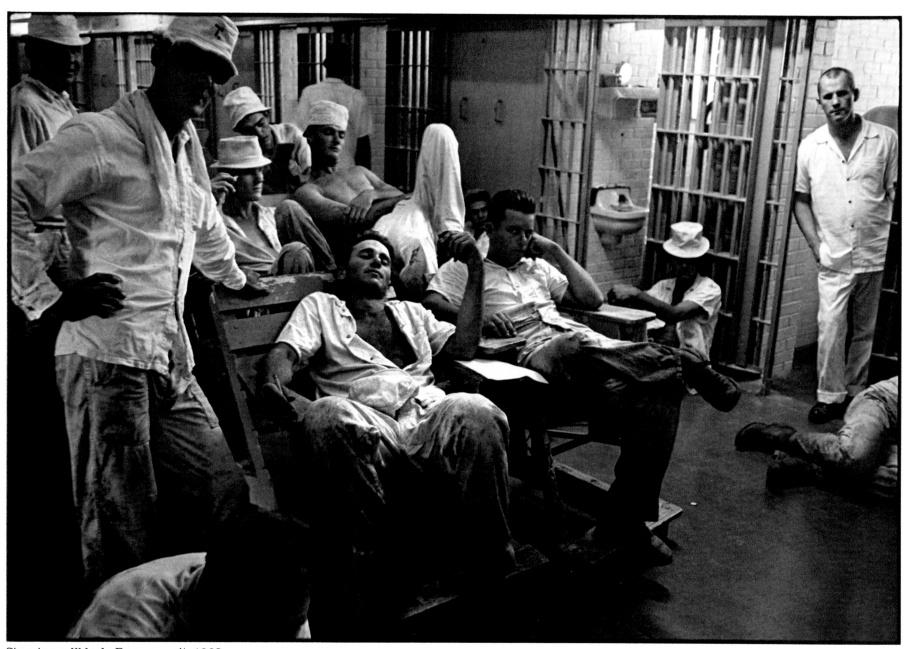

Six-wing cellblock, Ramsey unit, 1968

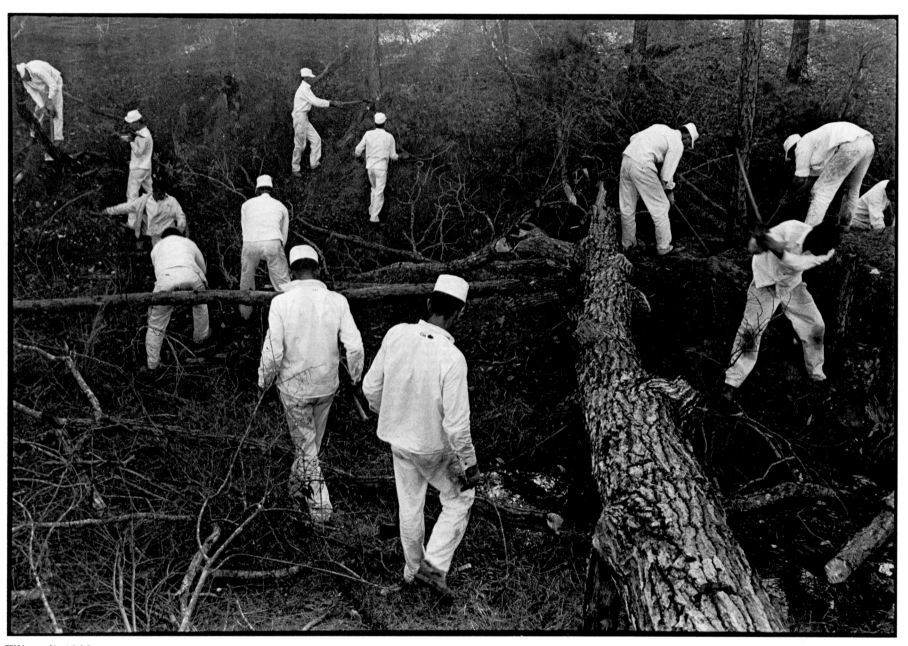

Ellis unit, 1968

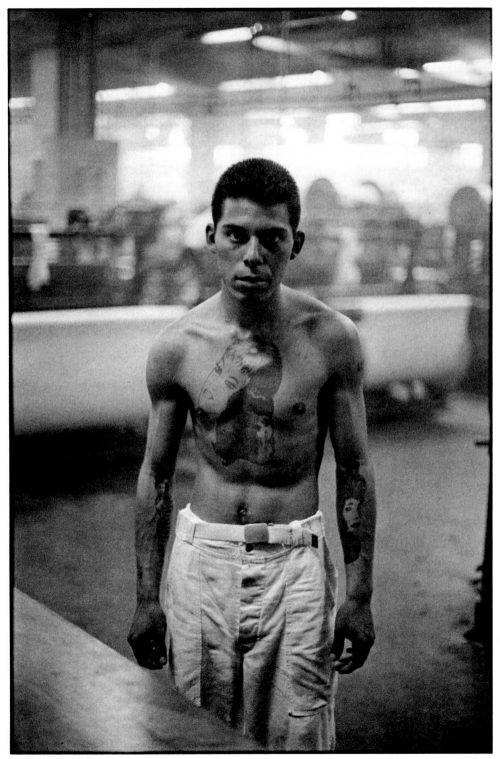

Textile mill, Walls unit, 1969

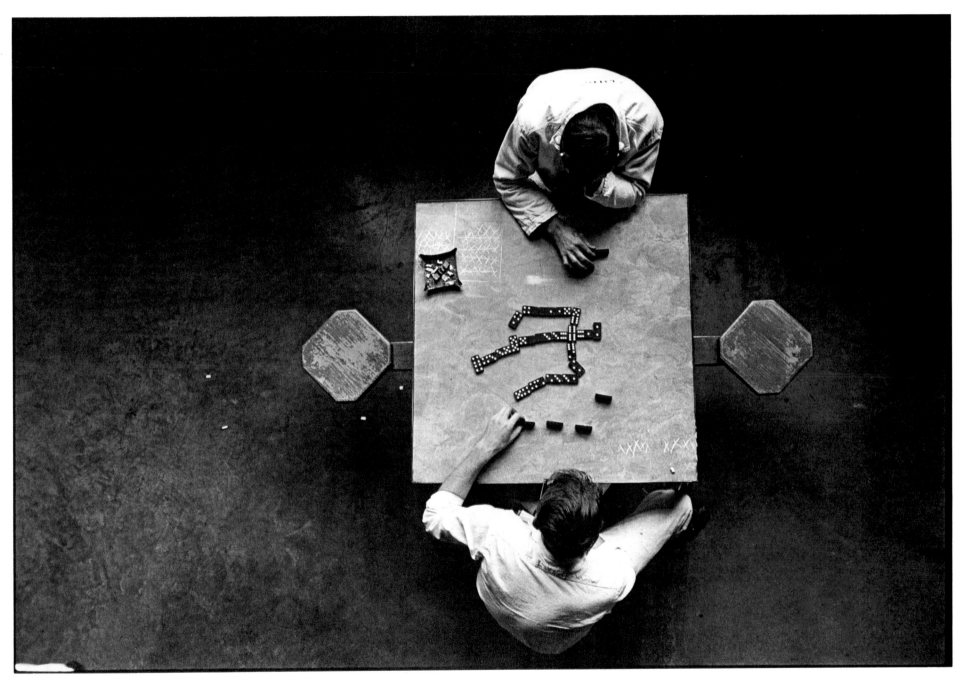

Walls unit, Huntsville, 1967

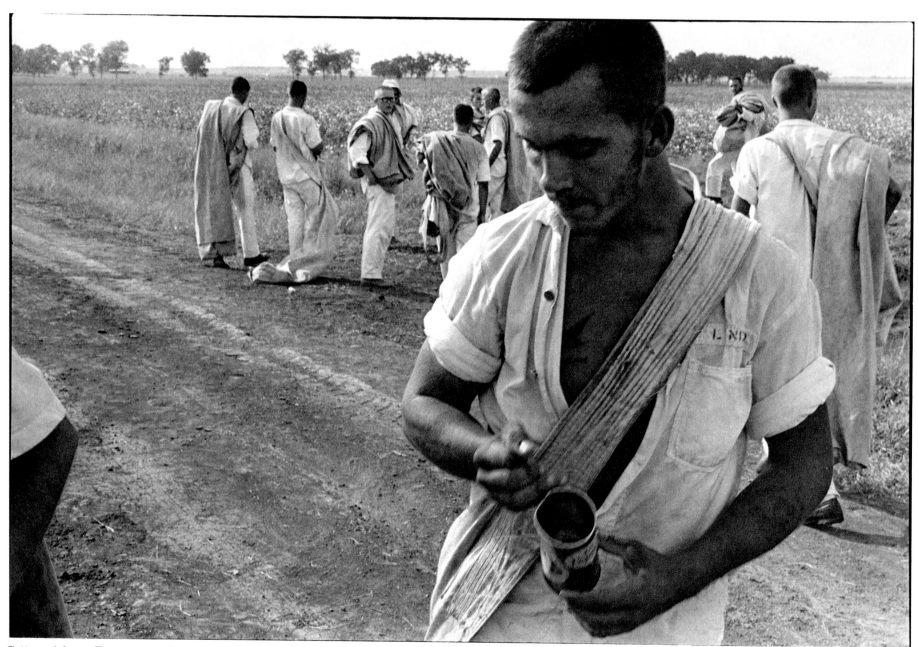

Cotton pickers, Ferguson unit, 1968

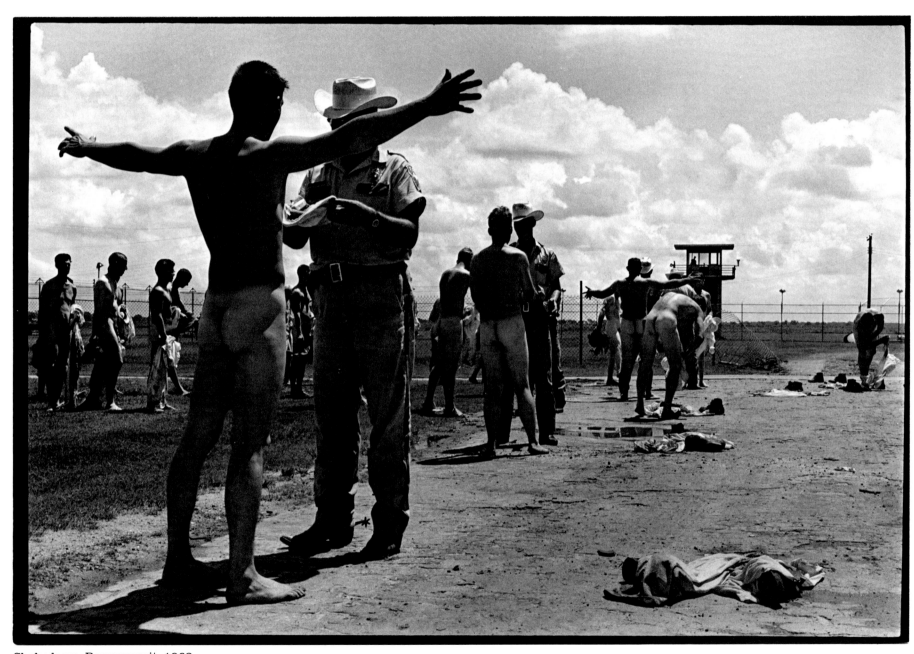

Shakedown, Ramsey unit, 1968

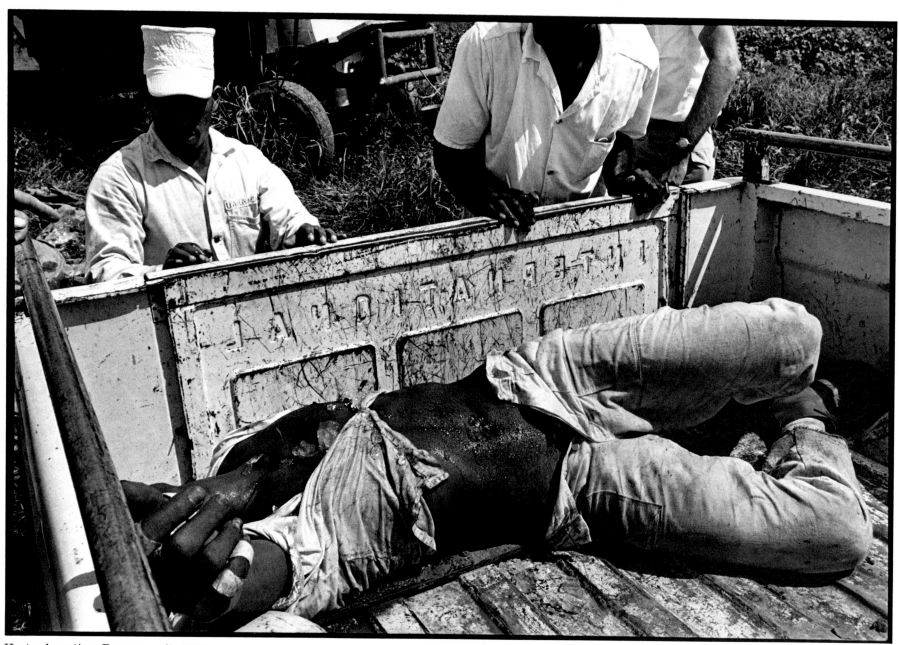

Heat exhaustion, Ramsey unit, 1968

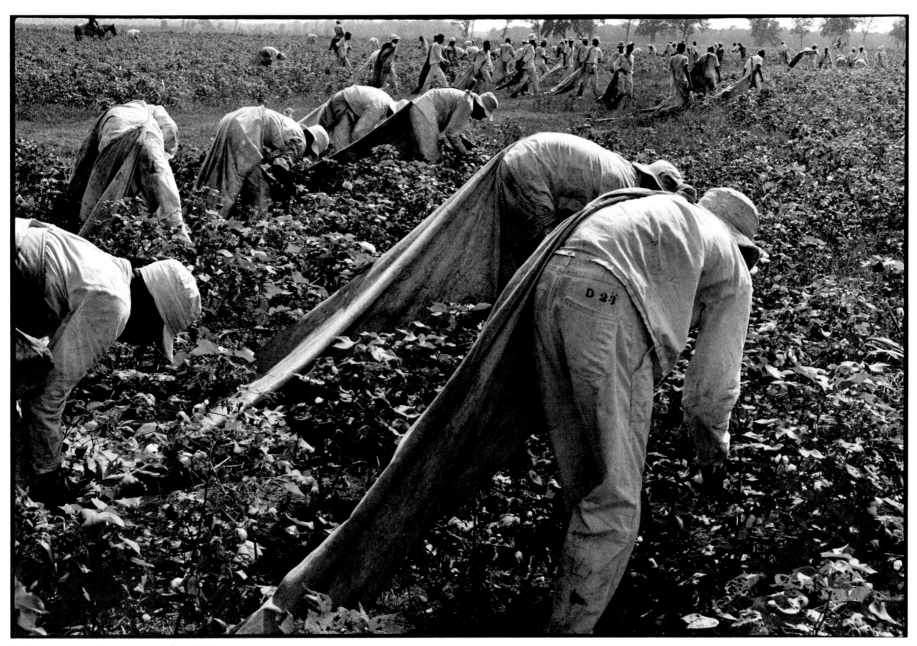

Cotton pickers, Ferguson unit, 1968

Jimmy Renton, an armed robber and lithographer I knew and one of my friends from the Huntsville unit, told me about a tattoo artist on Washington Street in Houston. Bill Sanders was not only a great tattoo artist, but a remarkable photographer. By taking Polaroid and color-negative pictures of his customers, many of them Houston hookers, he had amassed the greatest collection of photographs of tattooed women in the world. These he put up on the walls of his shop with colored thumbtacks. When the sunlight faded the pictures he would just replace them. "I've got stacks of them," he said. Bill Sanders knew more about what a photograph is than most museum curators do.

In 1969 I made my first film in Bill Sanders' tattoo shop. James Blue, the film maker, helped me get the money, a camera, and a crew. I took the footage I had shot and the camera I had borrowed from James and went to New York City. I moved in on Robert Frank, rented a Movieola and tried to make something out of Bill Sanders' tattoo shop. Soon afterward Bill Sanders died.

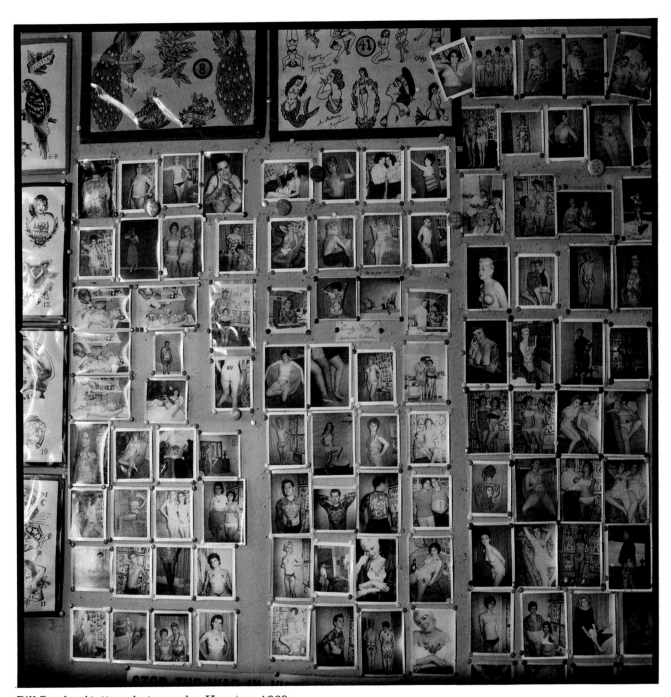

Bill Sanders' tattoo photographs, Houston, 1969

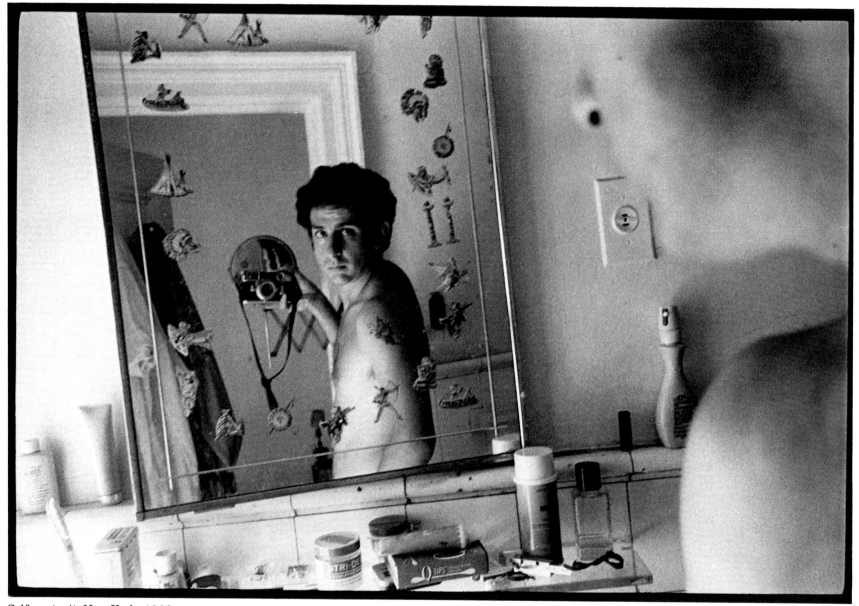

Self-portrait, New York, 1969

In New York City I plunged into a community of artists that swirled around the film makers Robert
Frank and Danny Seymour. My contribution was a film about an artist who thought he could create
"immortal life" by feeding film and recording tape into a machine. I showed it to Robert and halfway through
the screening the reel fell off the projector and tore the print in half. Seymour and Frank went on to make
films together, and Danny published his autobiography, *A Loud Song*, a classic of photoliterature. Then he
vanished. Robert moved to Nova Scotia and I went as far as I could in the opposite direction.

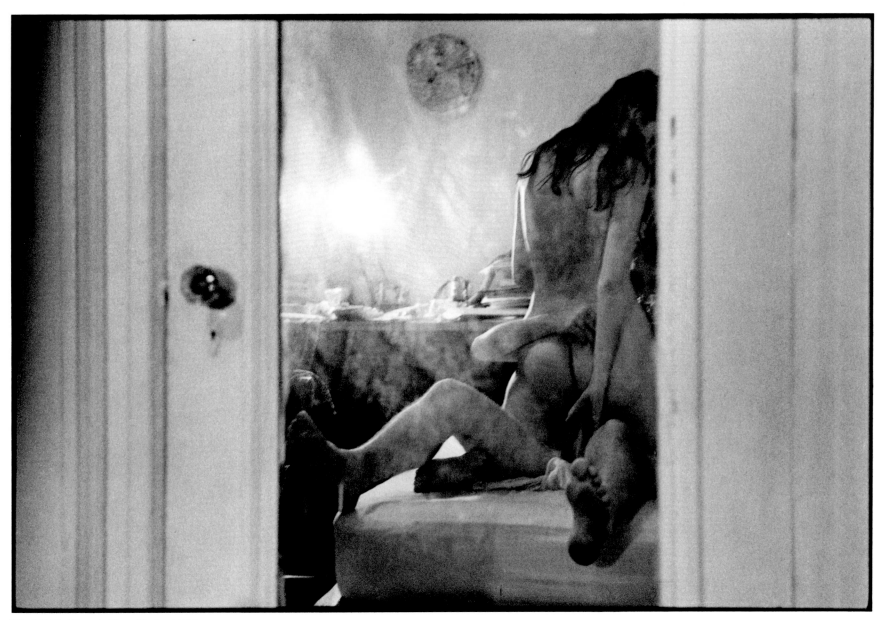

West 86th Street, New York, 1969

I moved to New Mexico in 1970 and looking back on it today that move probably made a fundamental change in my life. There in the desert I gave up photography to become a film maker. From then on, and with few exceptions, if a subject was strong enough for me I would deal with it in a film and not in photographs.

I went to New Mexico to get away from New York and to make a new world, which I did. I made a garden, and a house, and a family. Together we filled that world with goats and sheep, toads, lizards, and turtles. And after ten years when I left New Mexico and came back to New York, the only thing I brought with me that was able to live in those two opposite worlds was a snake, which eats mice.

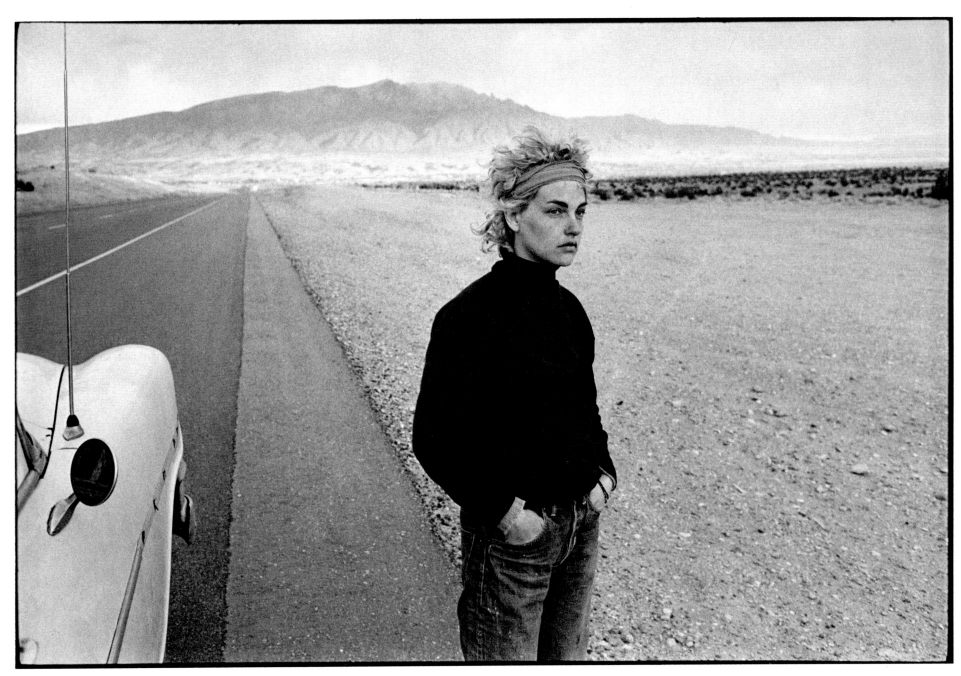

Stephanie, Sandoval County, New Mexico, 1970

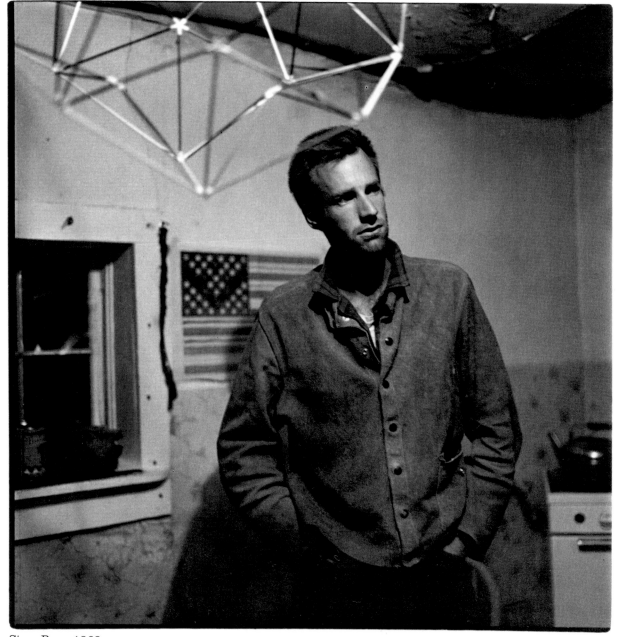

Steve Baer, 1969

Steve Baer, solar scientist, radical thinker, and inventor, whose solar factory refuses
government support and whose best inventions are pieced together out of junk—the true
spirit of the American West rising from the nuclear wasteland of New Mexico.

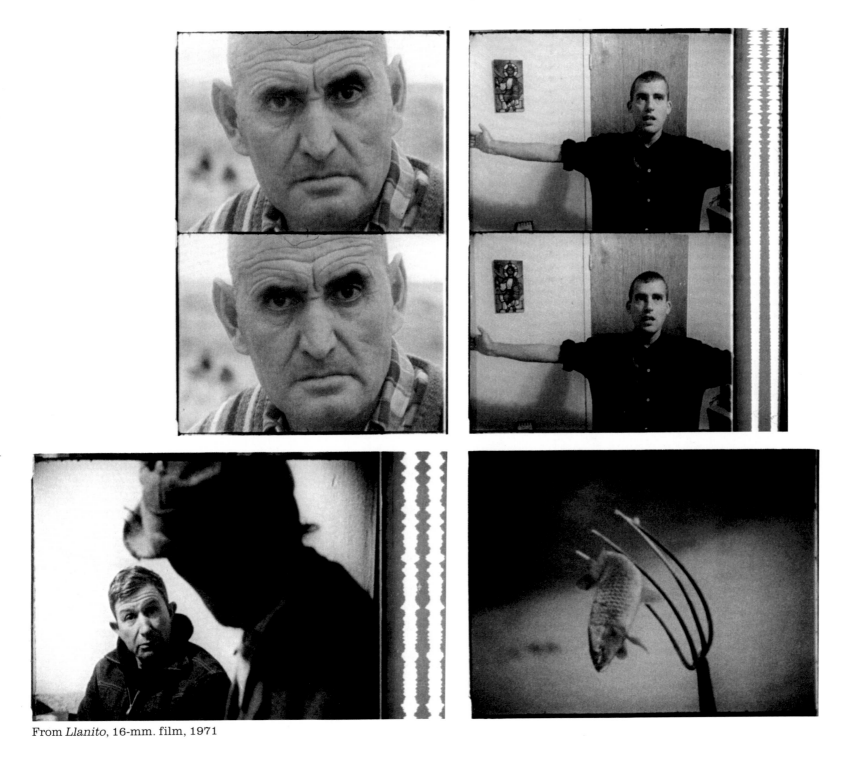

From *Llanito*, 16-mm. film, 1971

In 1971 I made *Llanito*, a 16-mm. film, with some of my Chicano and Pueblo Indian neighbors. The "Anglos" in the film all came from a local home for retarded boys. At the time it was meant to be a picture of America.

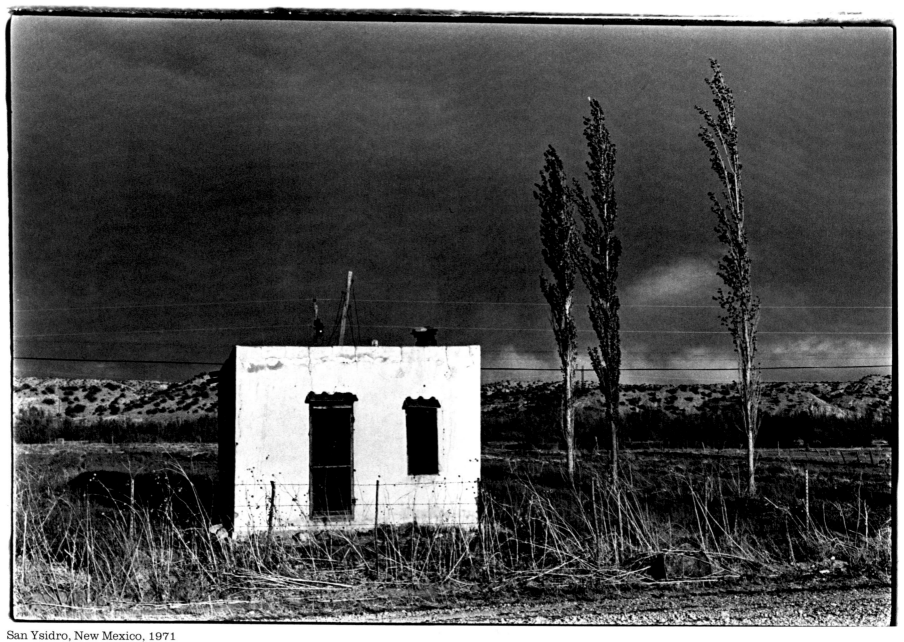

San Ysidro, New Mexico, 1971

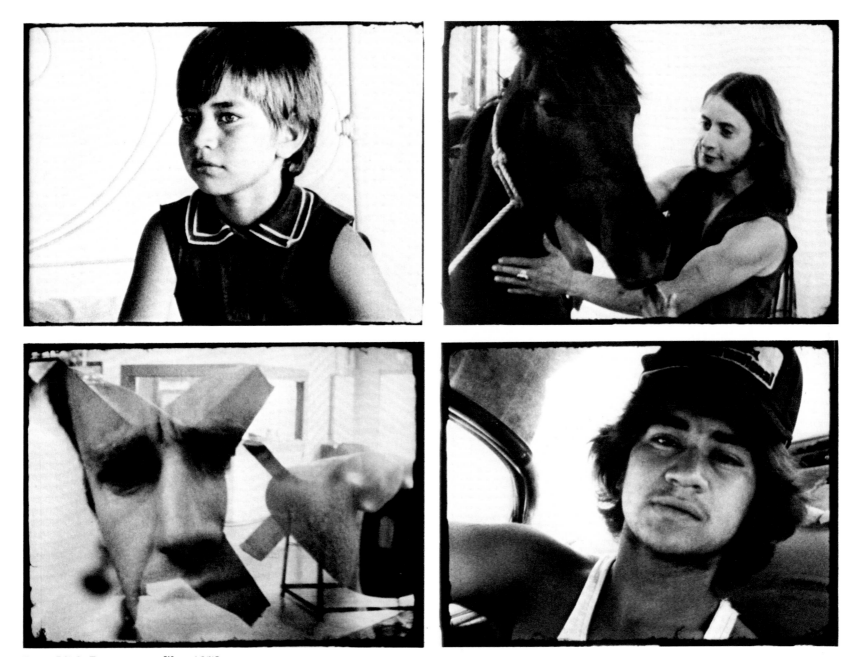

From *Little Boy*, 16-mm. film, 1978

Willie Jaramillo at twelve, a Chicano in northern New Mexico, Steve Baer with nuclear weapons, and Willie at sixteen. Willie's prize for winning a fight with the Bernalillo cops was three years in the prisons and mental hospitals of New Mexico. He survived the Santa Fe prison riot that left thirty mutilated dead and is now, at twenty-one, a Thorazine junkie, another certified graduate of America's vegetable factories.

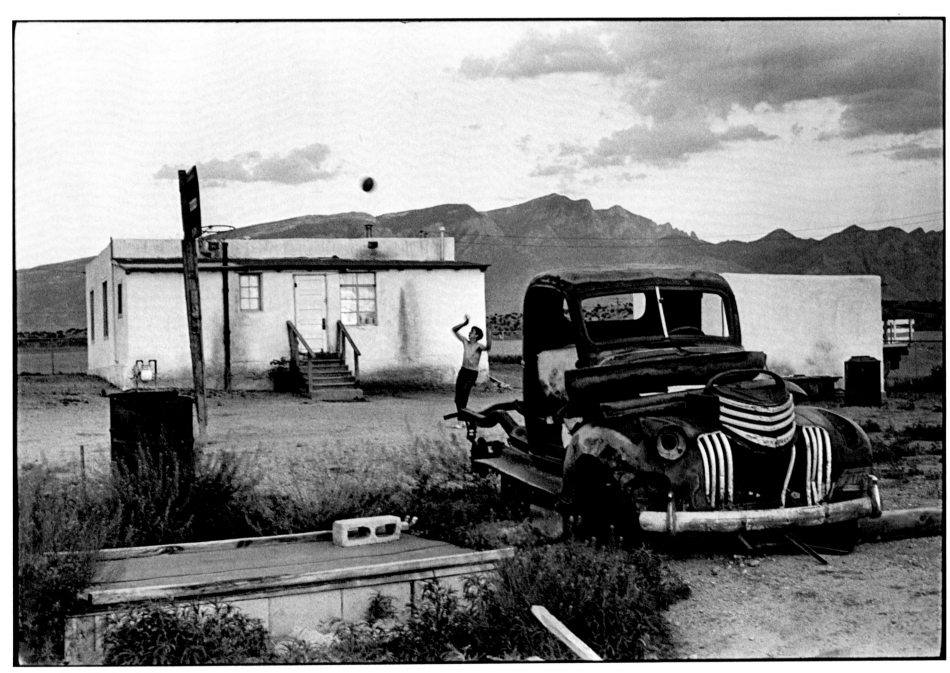

Llanito, New Mexico, 1970

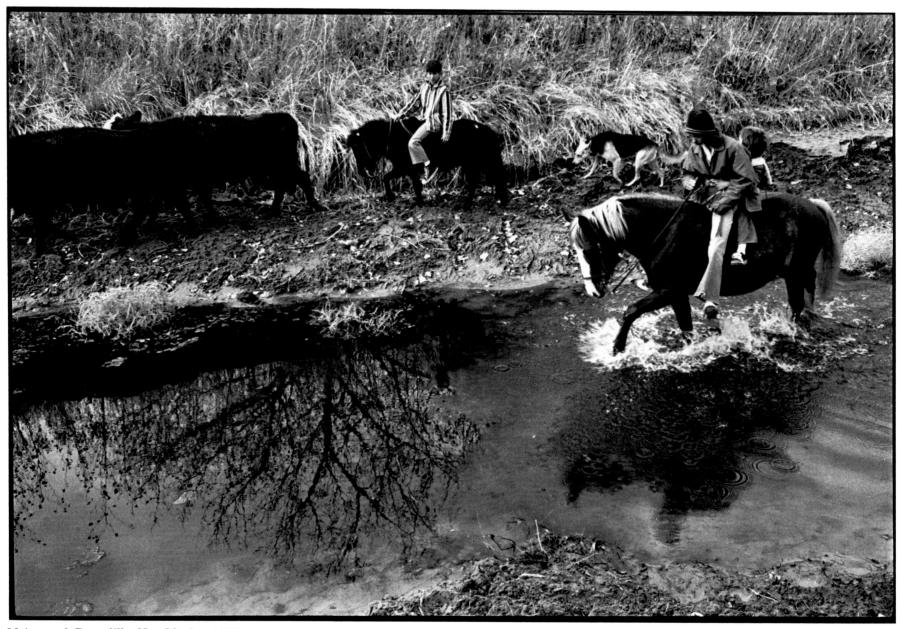

Main canal, Bernalillo, New Mexico, 1976

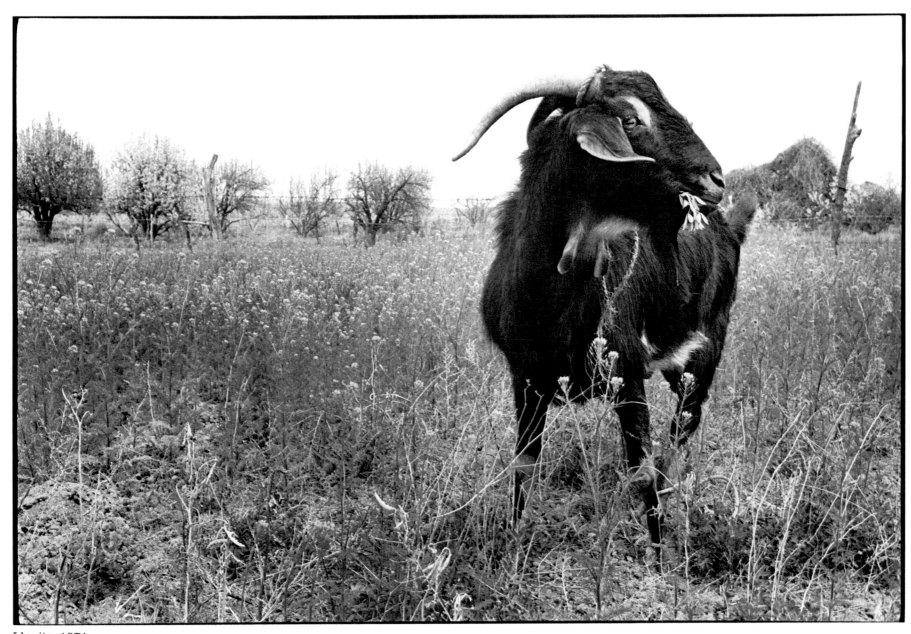

Llanito, 1971

In December 1972 the writer Harris Dulany and I went to Santa Marta on the coast of Colombia in search of a film that I wanted to make in a whorehouse. While we were there the idea for the film shifted to a group of abandoned children who slept on the cathedral steps and lived on table scraps. My still camera was expropriated by a gang of young thieves in the barrio, Harris was stabbed, and two Americans came floating out of the Rodardero Bay with bullets in their heads. Americans who had become bored with television were smoking more and more marijuana, and the Colombian coast was becoming the graveyard of entrepreneurs battling over exclusive rights to the new business.

Sixteen months later I returned to Santa Marta and shot 20,000 feet of film of Josélyn, one of the abandoned children, and his friends. Somehow these children, who lived off garbage and had absolutely nothing except a few pieces of string that they kept under a manhole cover they called the *oficina*, seemed better off than most Americans. Later I took my film to the Public Broadcasting System in Washington, D.C., but they said it needed a narrator and declined to show it.

Sometimes people ask me what happened to Josélyn, but I don't know. Maybe he's a beggar in the streets. Maybe he joined the guerrillas, but I doubt it. Maybe he's dead.

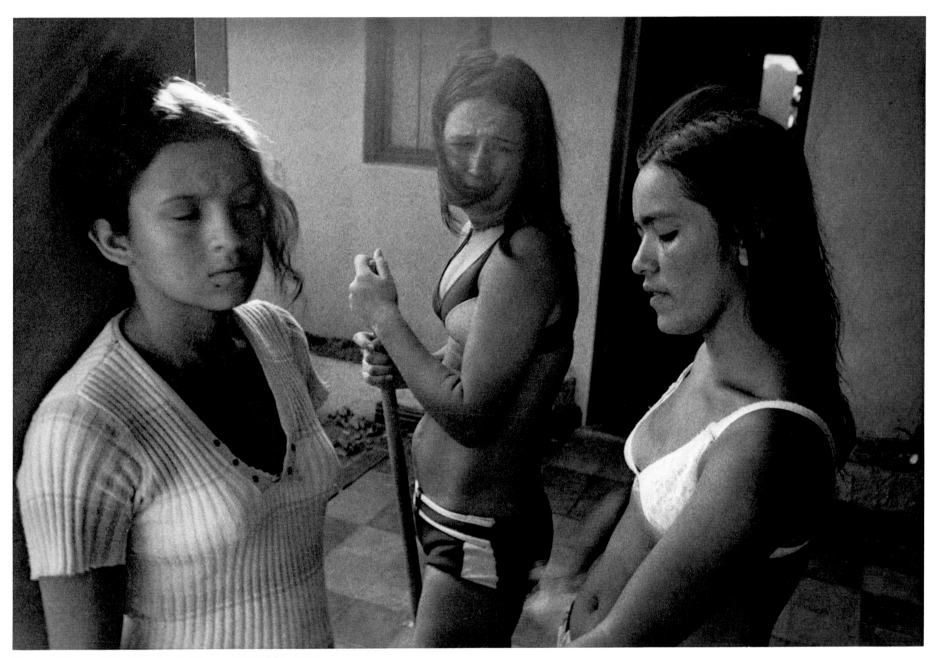

Gloria, Alba, and Bastala, Santa Marta, Colombia, 1972

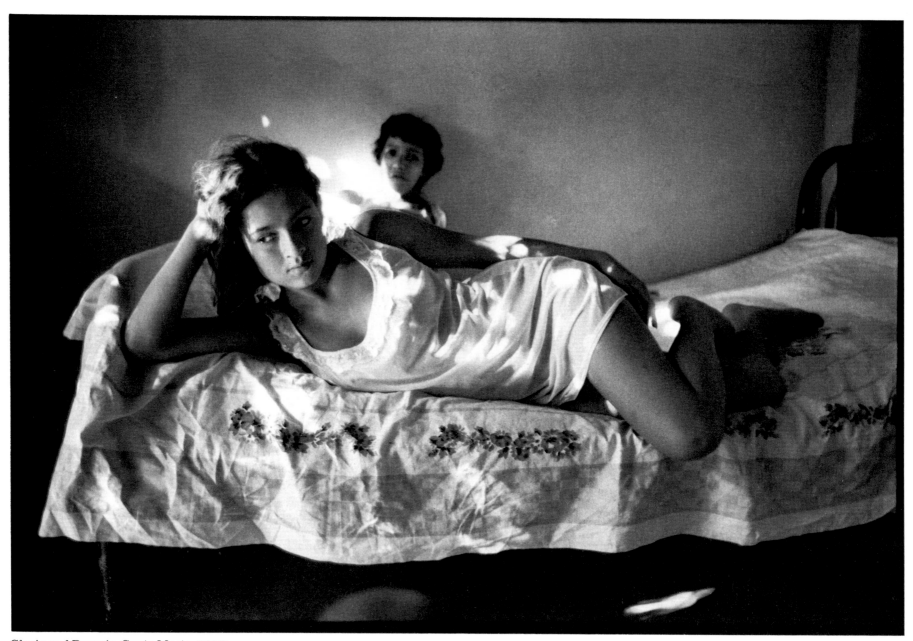

Gloria and Rosario, Santa Marta, 1972

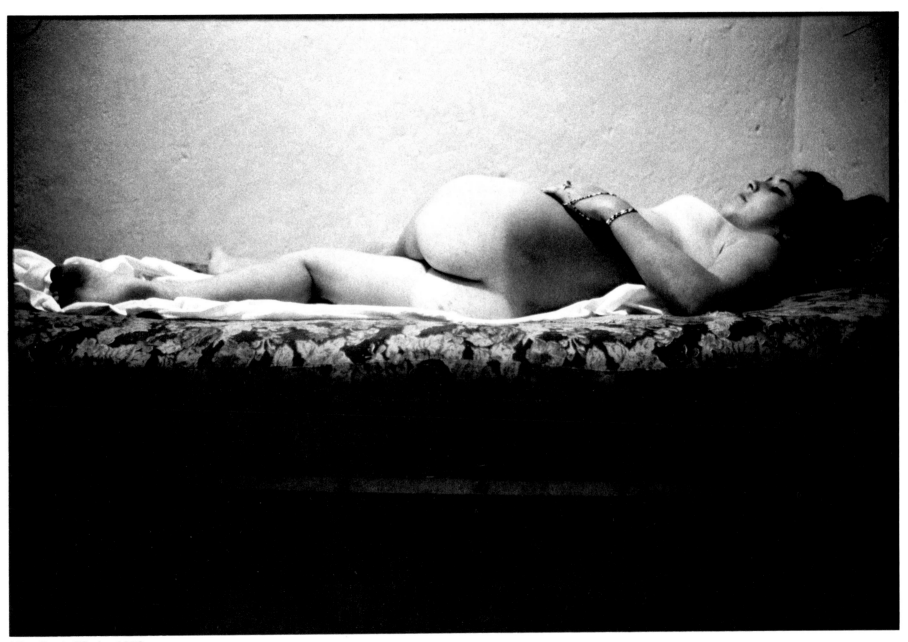

Alba, Santa Marta, 1972

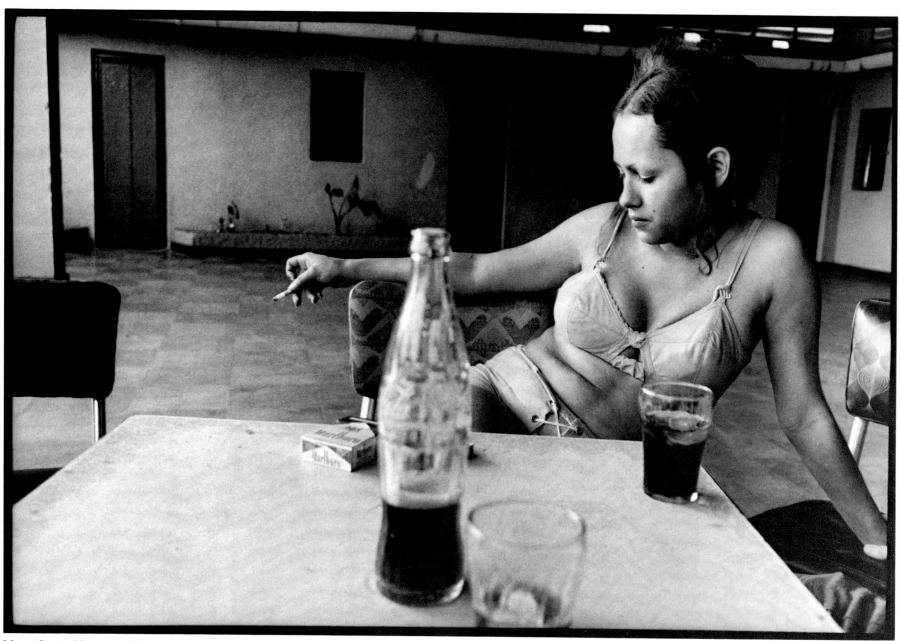

Mary, Santa Marta, 1972

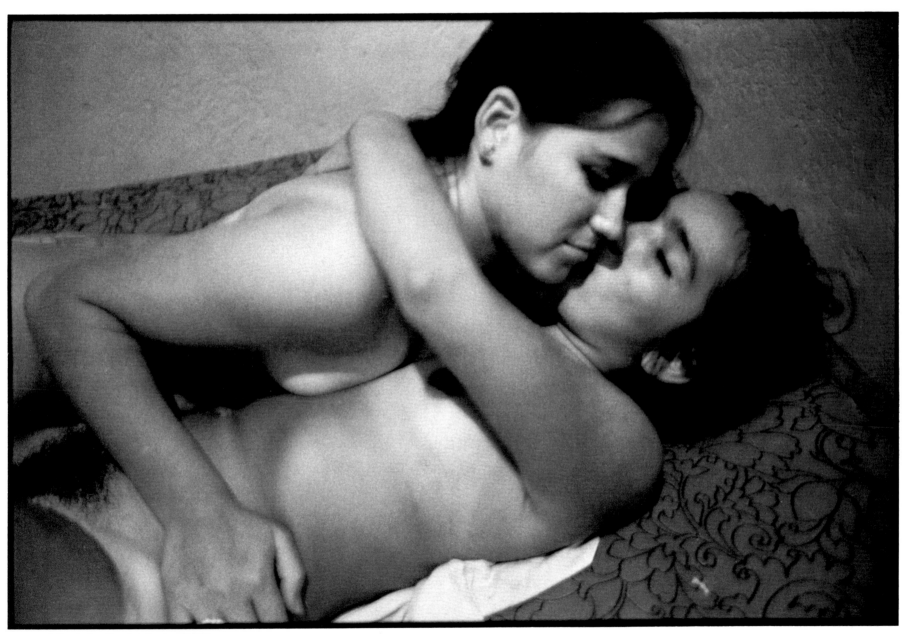

Alba and Bastala, Santa Marta, 1972

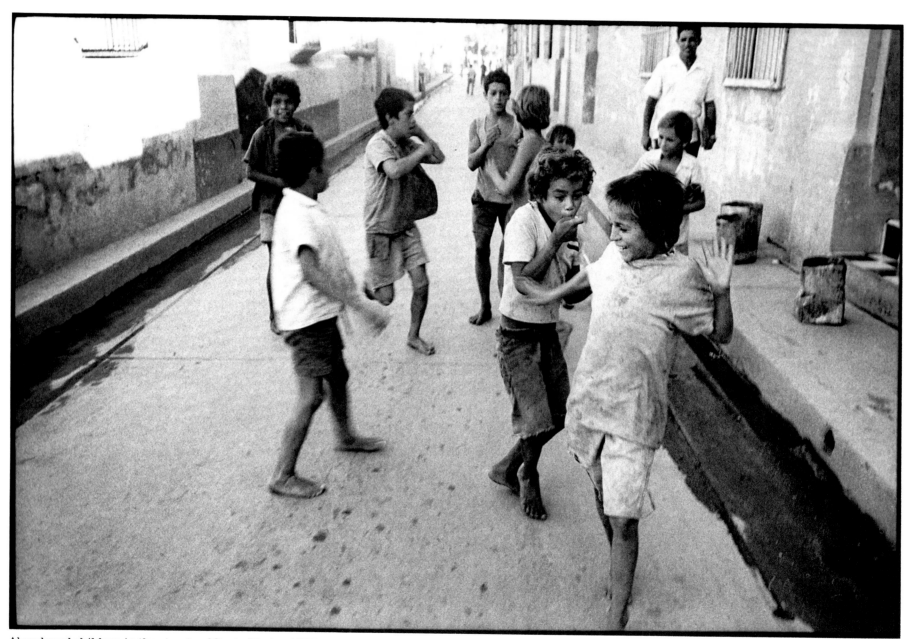

Abandoned children in the streets of Santa Marta, 1972

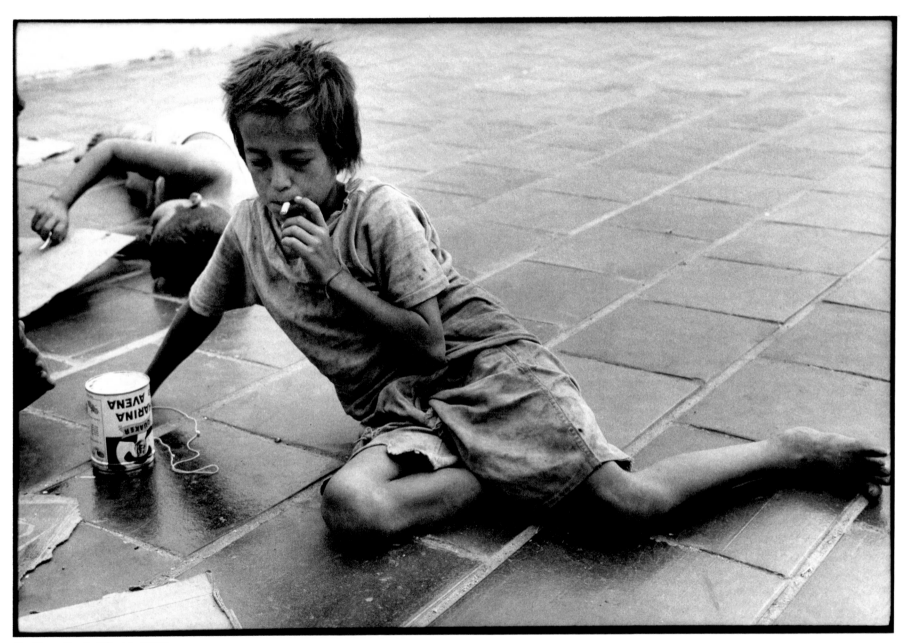

Josélyn, Santa Marta, 1972

A Leica feels like a pistol in your pocket, and there is something comforting about a view camera, which across my shoulder feels like an ax. In 1973 Harris and I dumped the view camera into a Chevy and went south to Mexico.

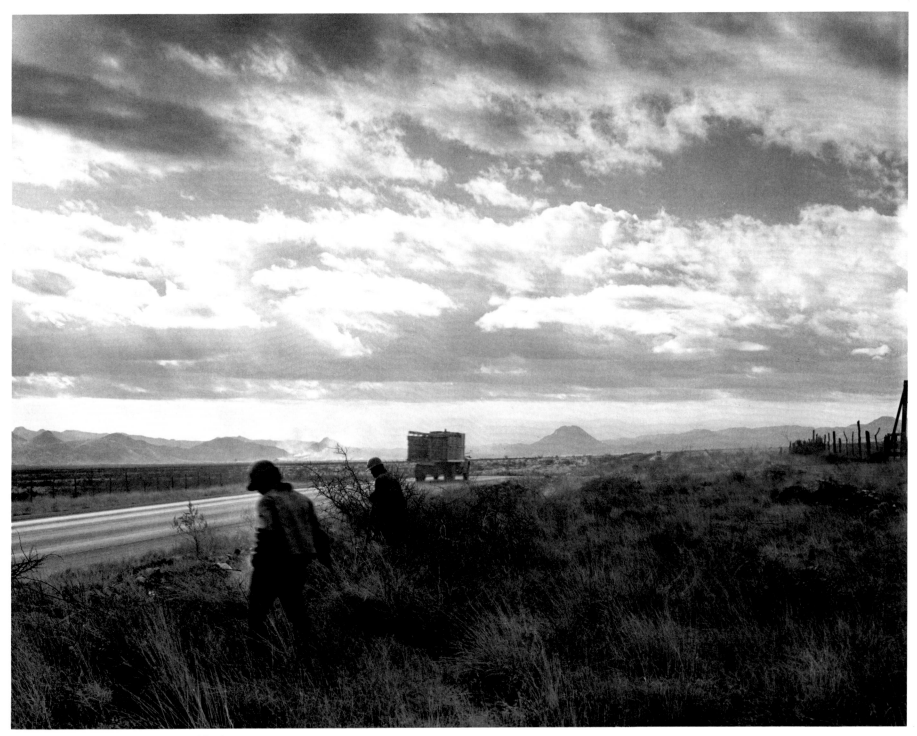

Road from Juárez to Chihuahua, Mexico, 1973

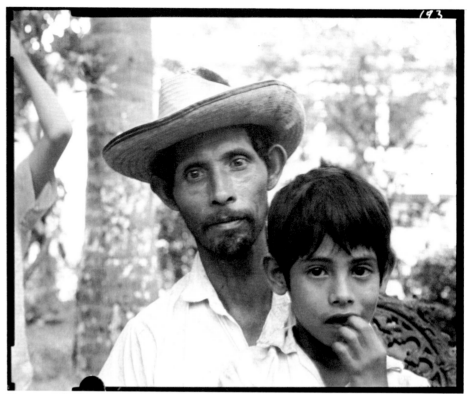

Tamazunchale, 1973

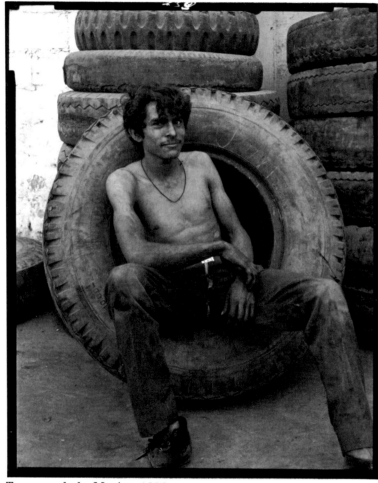

Tamazunchale, Mexico, 1973

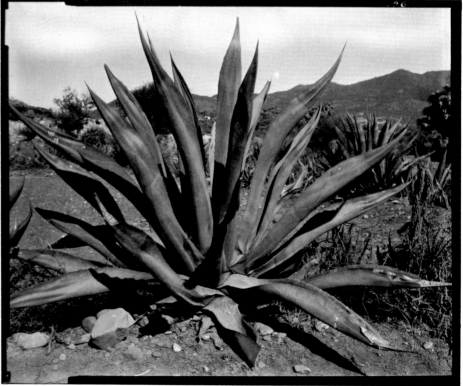

Mexico, 1972

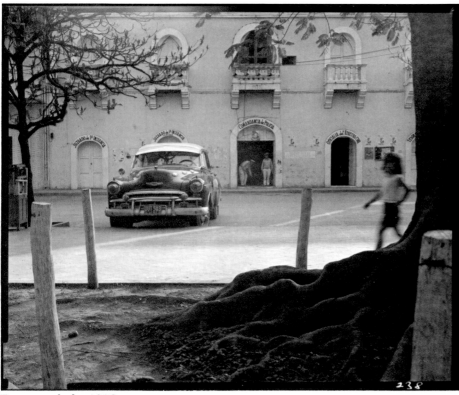

Tamazunchale, 1973

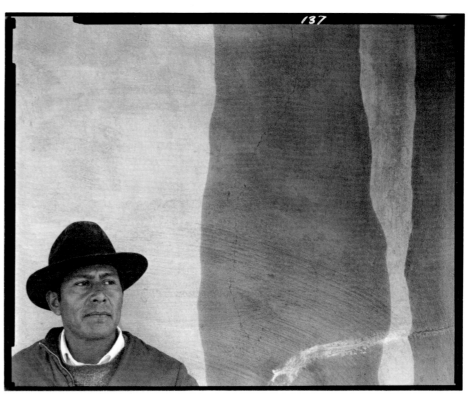

Mexican worker, New Mexico, 1973

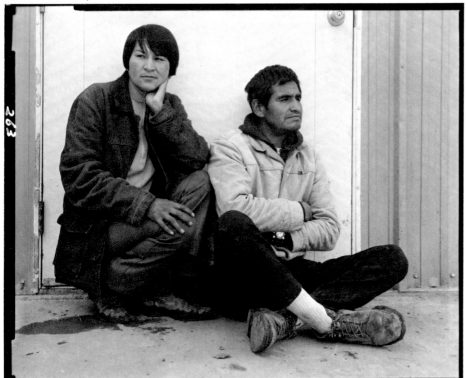

Jicarilla Apache medicine man and sister, Dulce, New Mexico, 1973

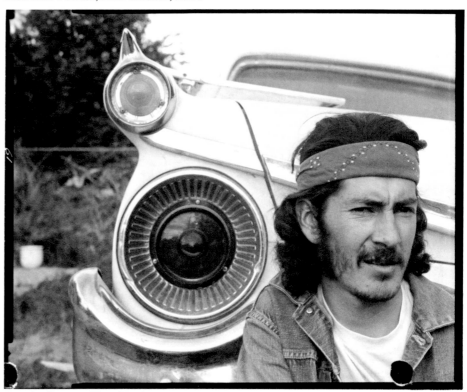

Randy Chavez, New Mexico, 1973

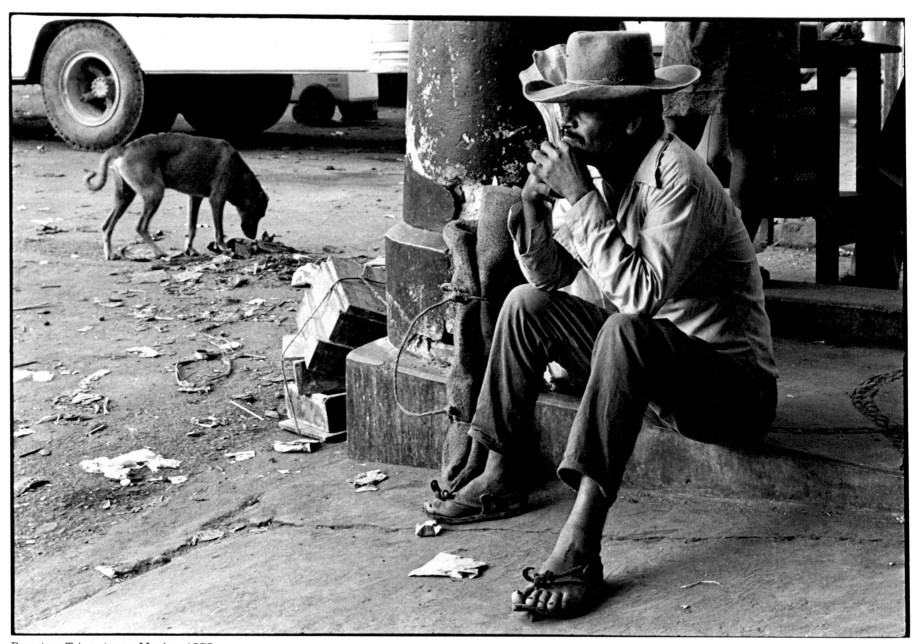

Bus stop, Tejuantepec, Mexico, 1978

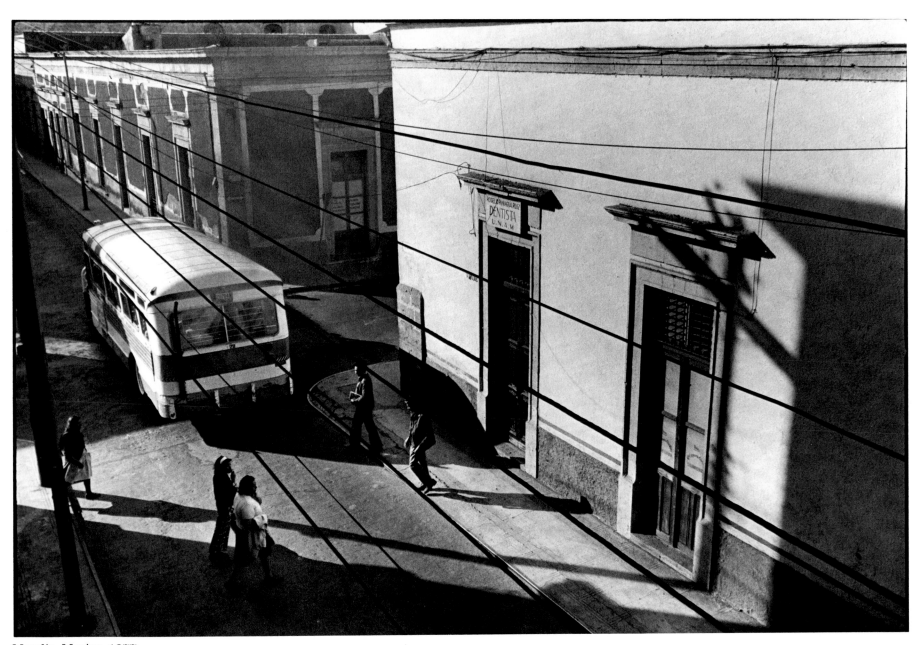

Morelia, Mexico, 1977

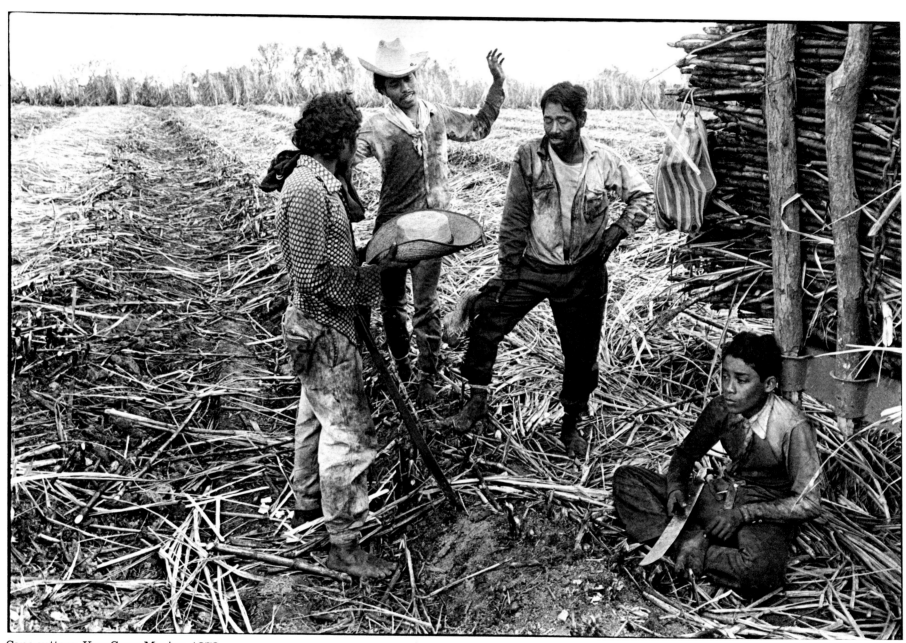

Cane cutters, Vera Cruz, Mexico, 1978

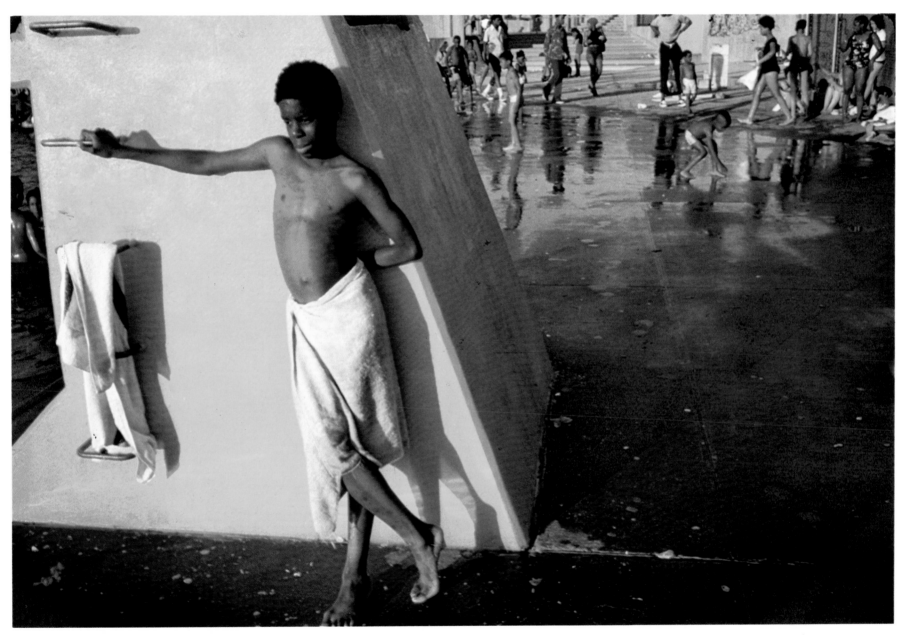

Bedford Stuyvesant, Brooklyn, New York, 1975

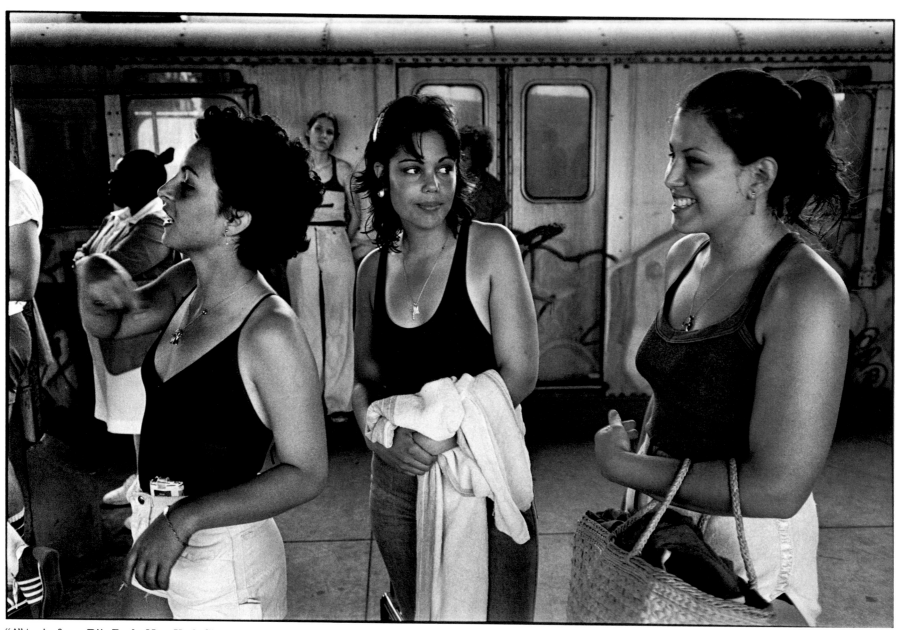

"A" train from Riis Park, New York City, 1980

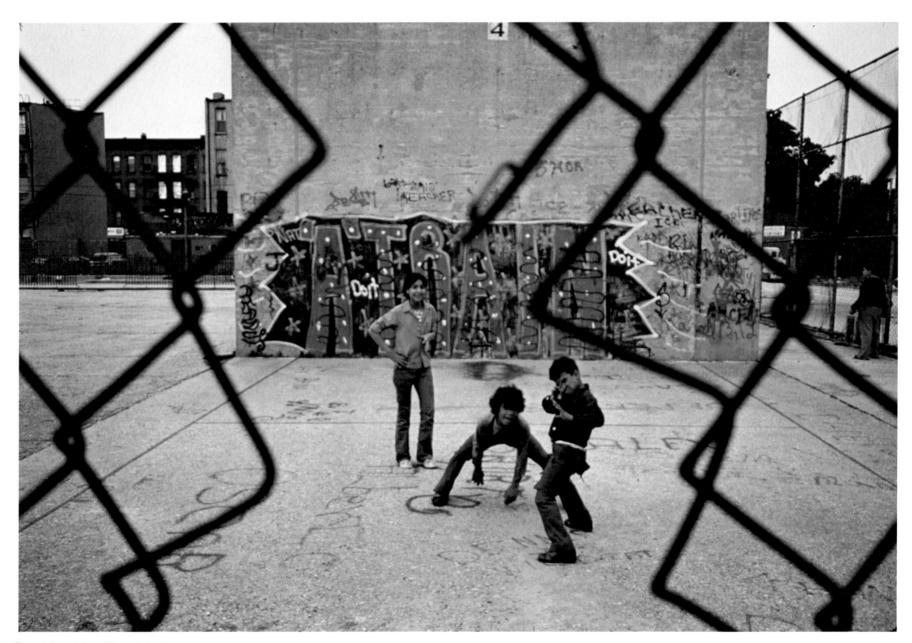

Brooklyn, New York, 1975

My friends and family have become a subject for me, not out of any sense of desperation or their appropriateness as subjects, but out of that hardest of feelings to transcribe with detachment, happiness.

The subject I once so energetically sought outside myself I now pursue within myself. When I was twenty-five I wanted to know what the subject had to say. Now, for better or worse, I am becoming more interested in what I have to say.

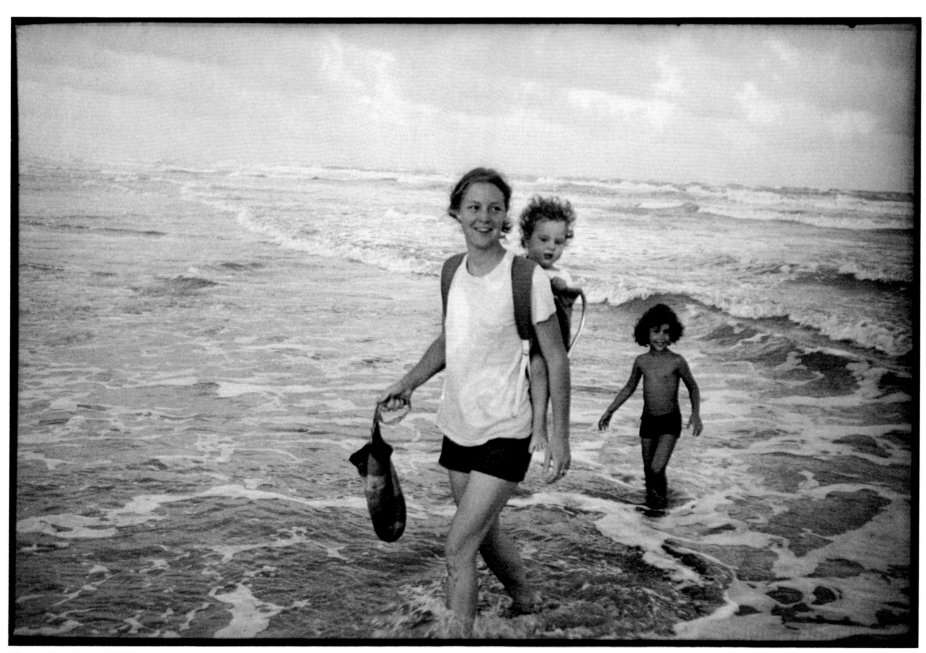

Nancy, Raphe, and Gabe, Port Arkansas, Texas, September, 1977

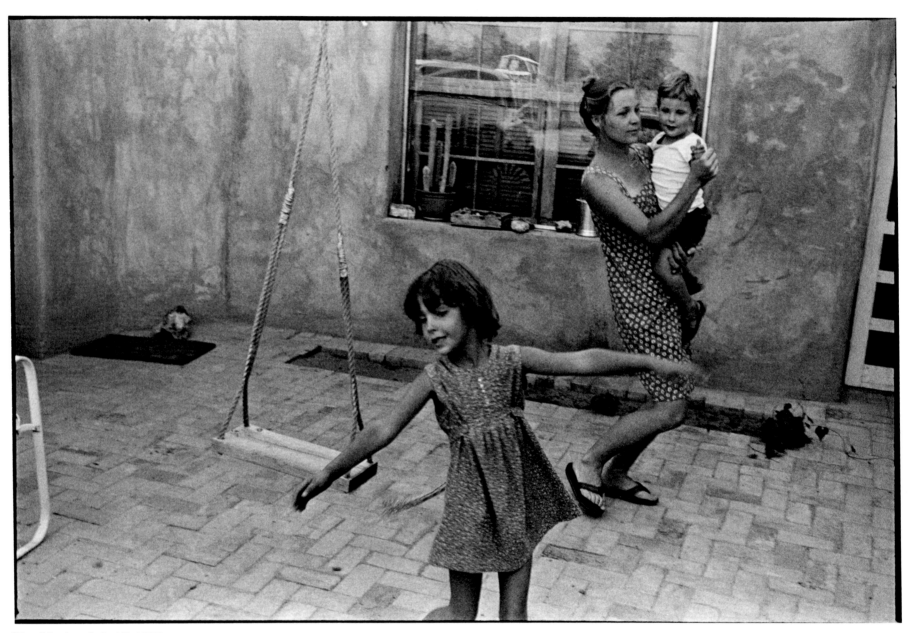

New Mexico, July 16, 1978

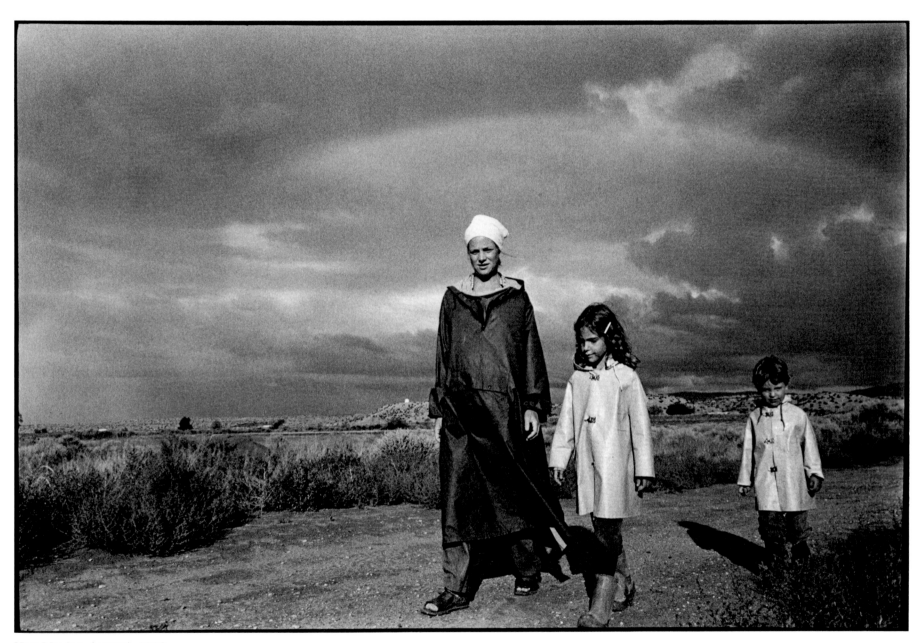

New Mexico, August, 1979

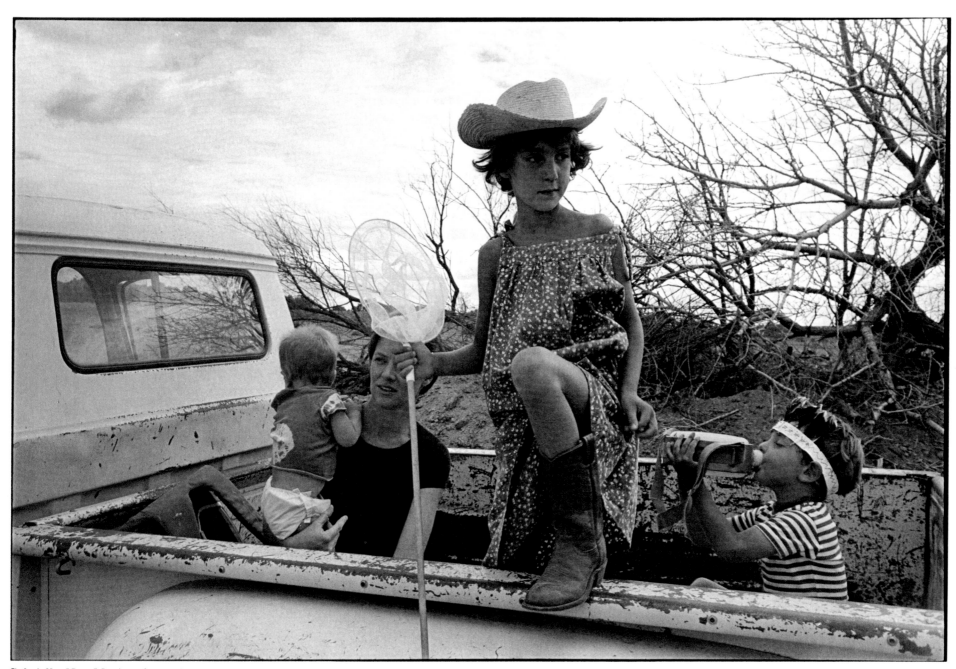

Gabrielle, New Mexico, August 1980

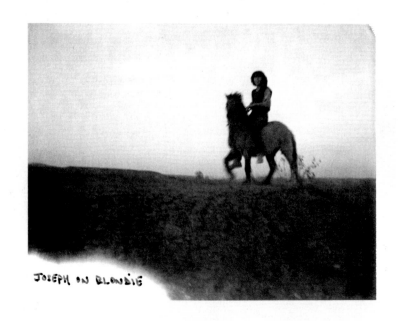

JOSEPH ON BLONDIE

JAN. 1979

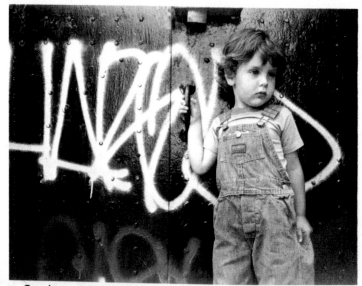

RAphe NYC 1978

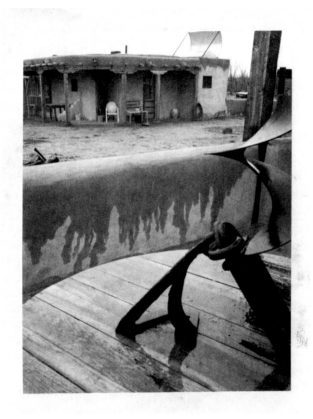

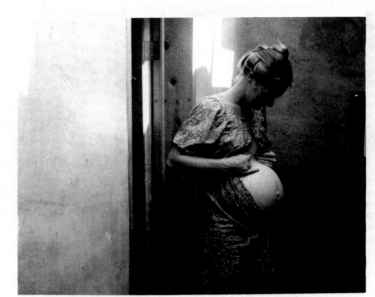

NANCY AUG. '79

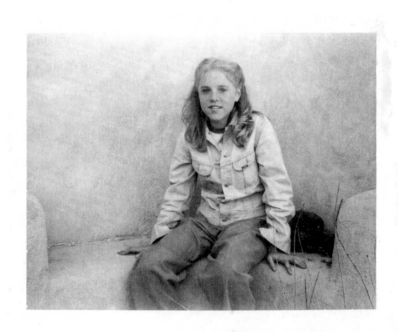

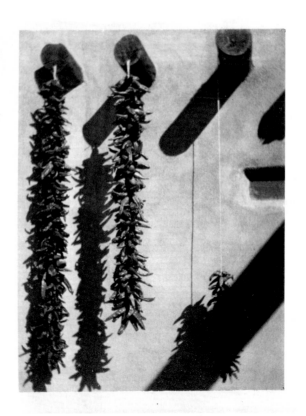

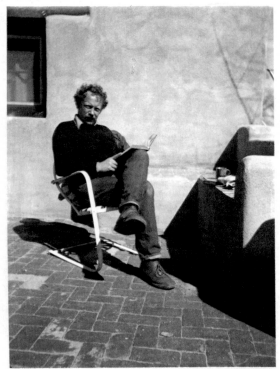

HARRIS DULANY JAN. 1979

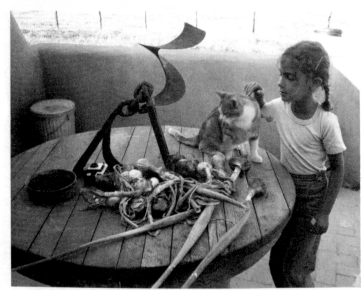

GABE AND EASTMAN

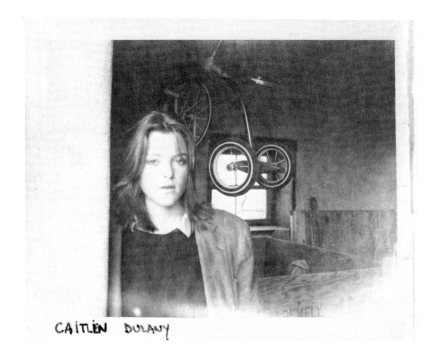

CAITLEN DULANY

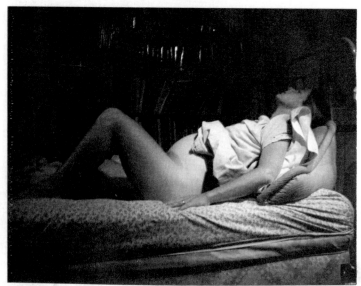

SEPT. 10 1979

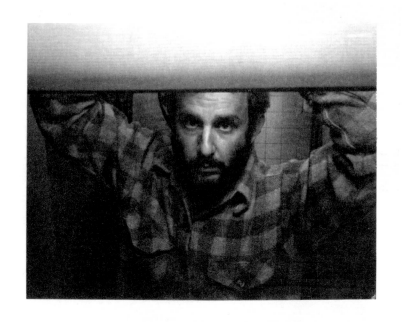

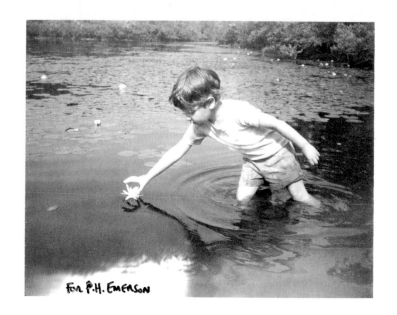

For P.H. Emerson

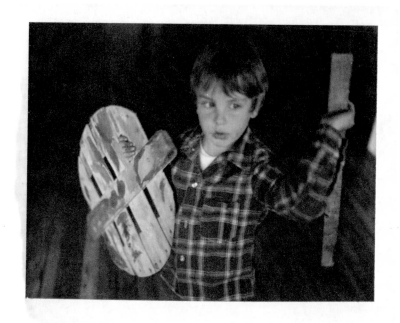

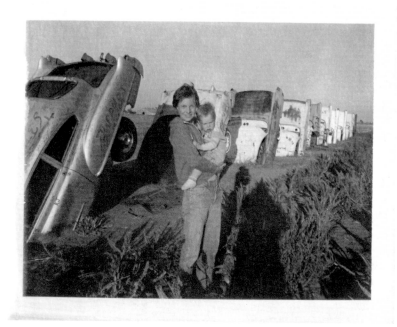

A great windswept, treeless plain lies in the Andes Mountains at heights of twelve and thirteen thousand feet, crossing from Peru into Bolivia on which is situated Lake Titicaca. This is the great Altiplano, where most of these pictures were made. La Paz, the largest city of Bolivia, is in a huge ditch, or arroyo, in the Altiplano. I first read about the Altiplano in the writings of the late William O. Douglas, and I always wanted to go there to make pictures. I also wanted to catch a trout in Lake Titicaca.

In November 1979 an army colonel took over the Bolivian government and in the following weeks killed three hundred people in the streets of La Paz. I arrived in the city about a month after the colonel had resigned, and when I reached Titicaca, I learned that the trout were all gone because the campesinos had been using dynamite to catch them.

In July 1980 another Fascist coup, this one arranged by our new ally Argentina, was more successful, and the democracy of Bolivia was finally crushed. Unfortunately, the United States was more than a mere observer in this crisis. The sad truth is that in the 1960s we created the Bolivian army and were instrumental in creating the military regimes that border on Bolivia to the east, south, and west. And that Pandora's box, once opened, is not so easy to close.

As I write, Fascism continues to grip Bolivia while our government supports the murderous junta of El Salvador. This is a policy deadly to the youth of Latin America. If the power we Americans have over our own government is so weak, then the power we have over our own lives is that much more important. As Fascism continues to cast its grotesque shadow across South America, how long can it be until that shadow extends north and covers us all?

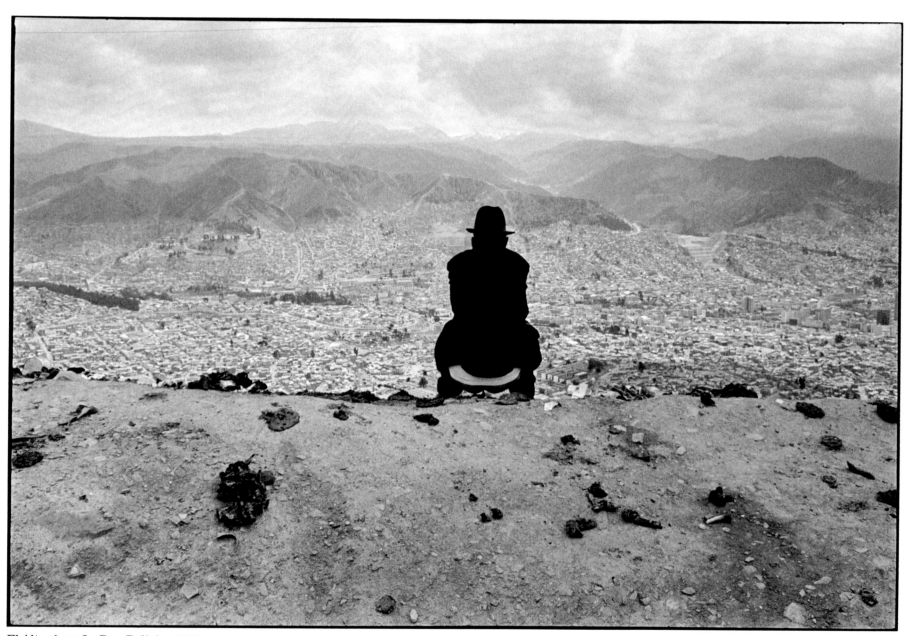

El Alto above La Paz, Bolivia, 1979

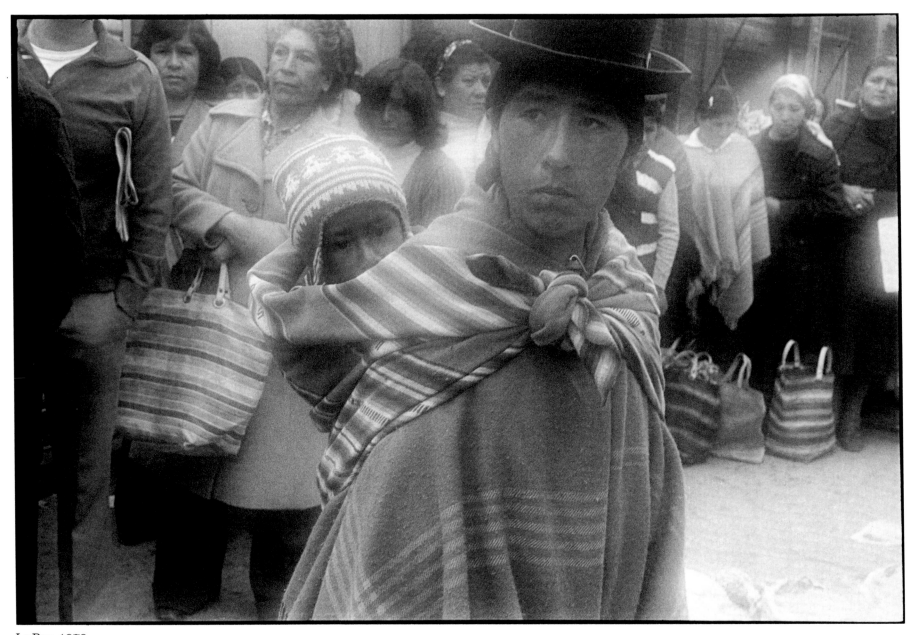

La Paz, 1979

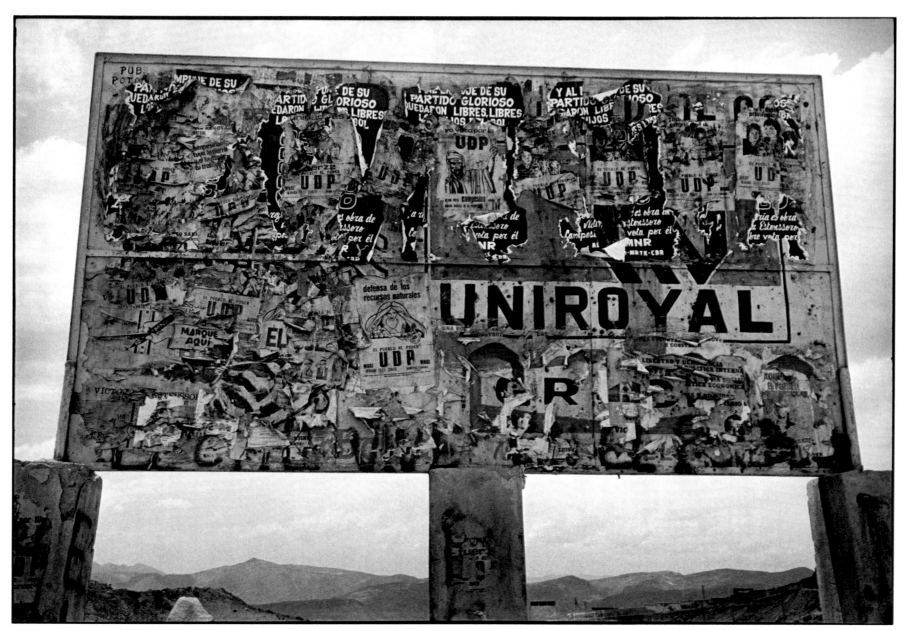

Near the Cerro Rico, Potosí, 1980

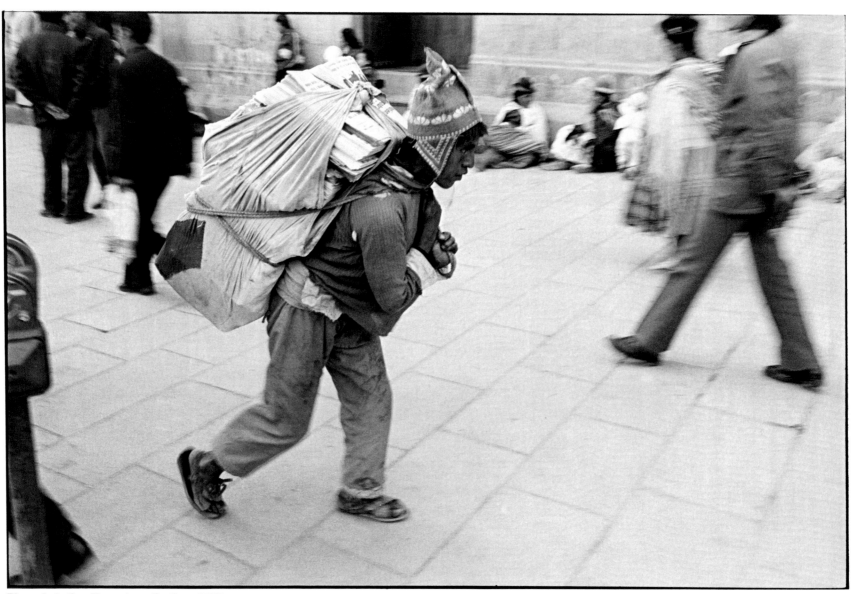

Plaza de la San Francisco, La Paz, 1979

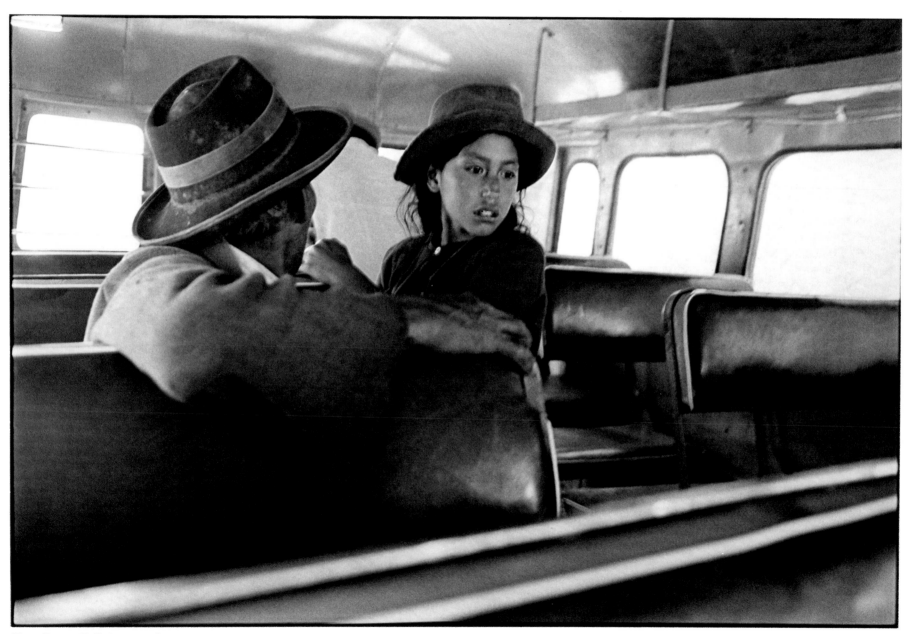

Near Sucre, Bolivia, 1979/80

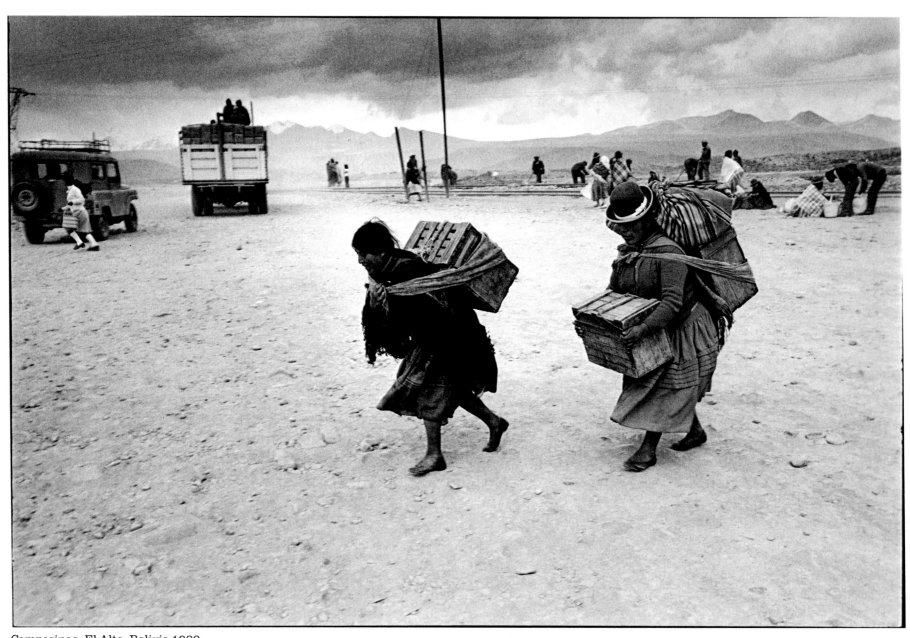

Campesinas, El Alto, Bolivia 1980

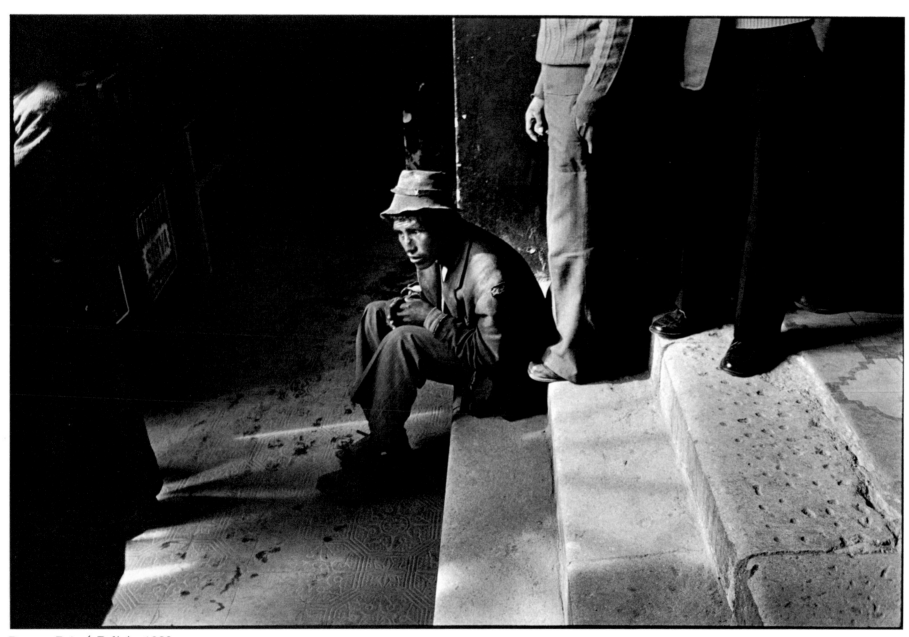

Beggar, Potosí, Bolivia, 1980

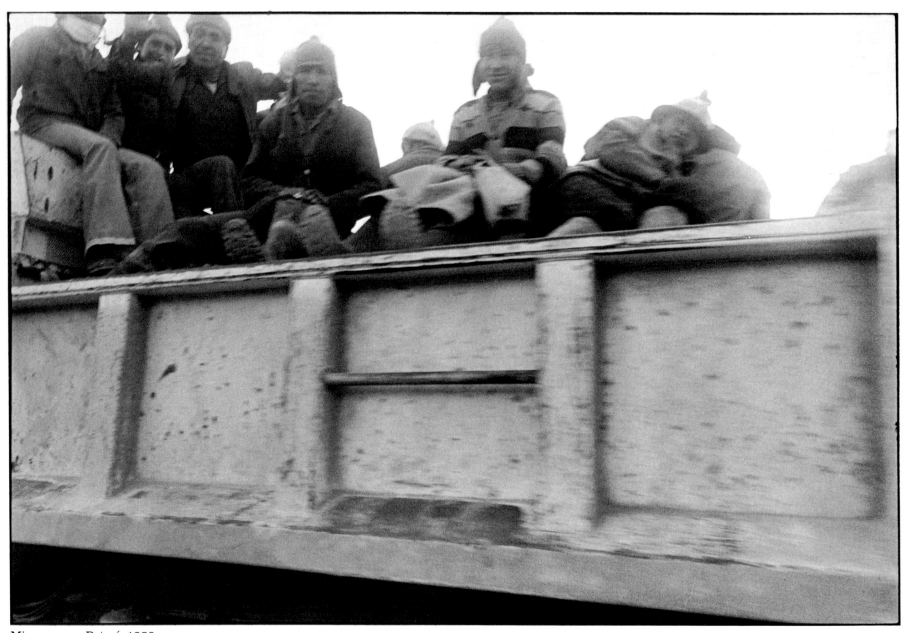

Miners, near Potosí, 1980

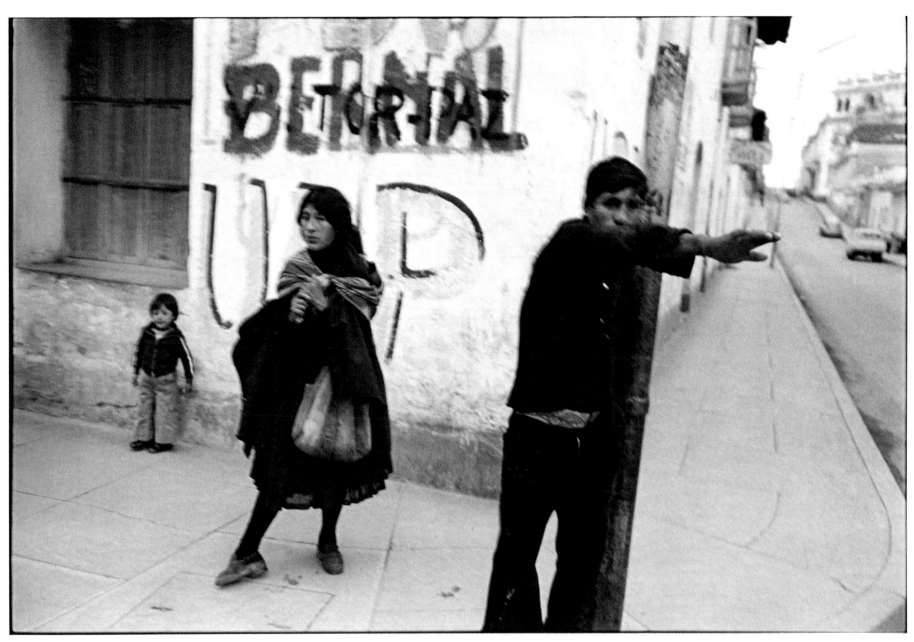

New Year's morning, Sucre, 1980

After twenty years I have returned to New York City, where I was born. To me New York is the spiritual heart of our democracy. Through her the subways tunnel, carrying their daily load of humanity. It's a rough town to photograph.

As I ride through the Bronx, where the trains are elevated and real sunlight comes crashing through the windows, I think of a good friend gone blind who told me that the only thing he regrets is no longer being able to look into the human face.

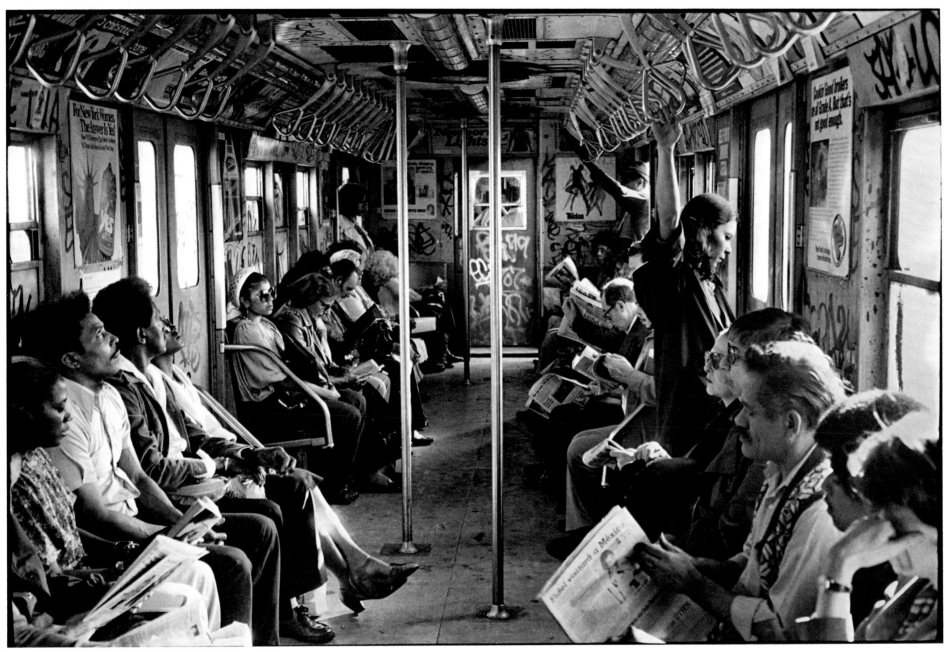

IRT ②, New York City, 1980

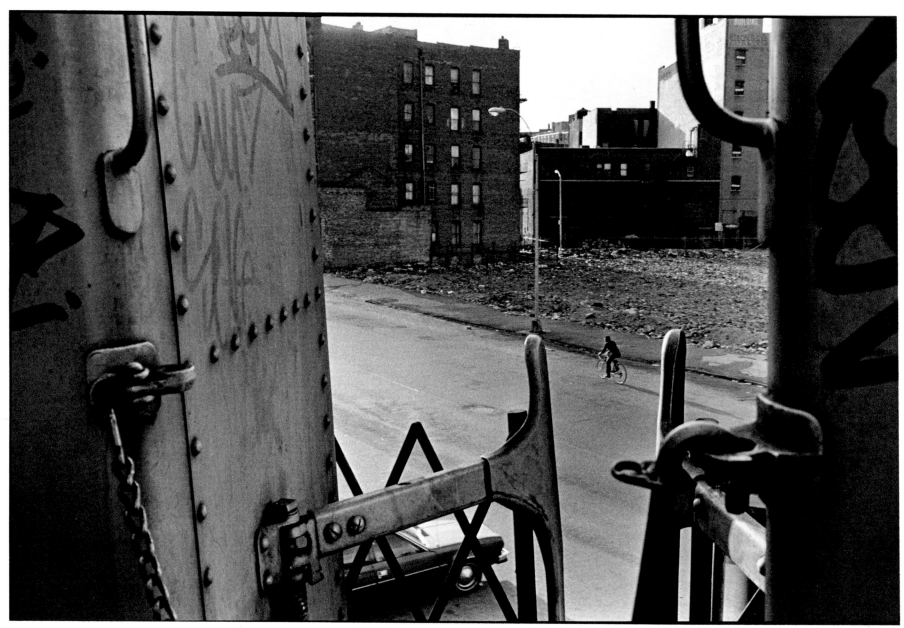

IRT ②, South Bronx, 1980

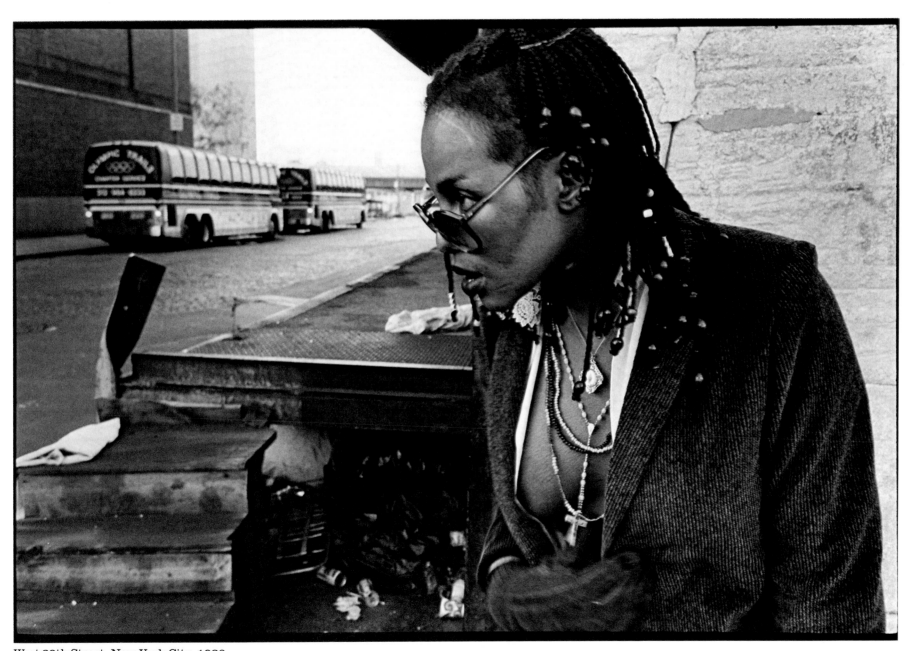

West 39th Street, New York City, 1980

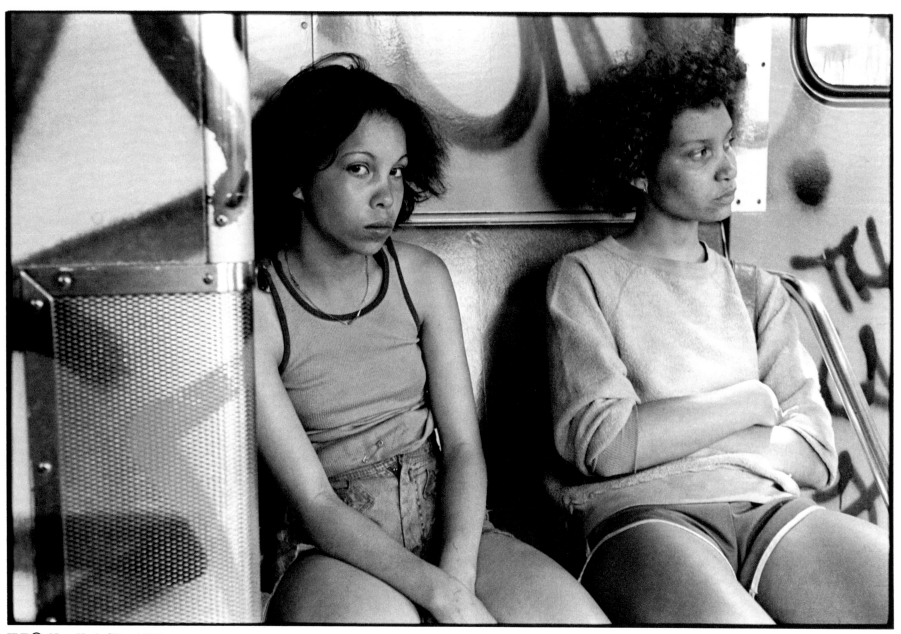

IRT ②, New York City, 1980

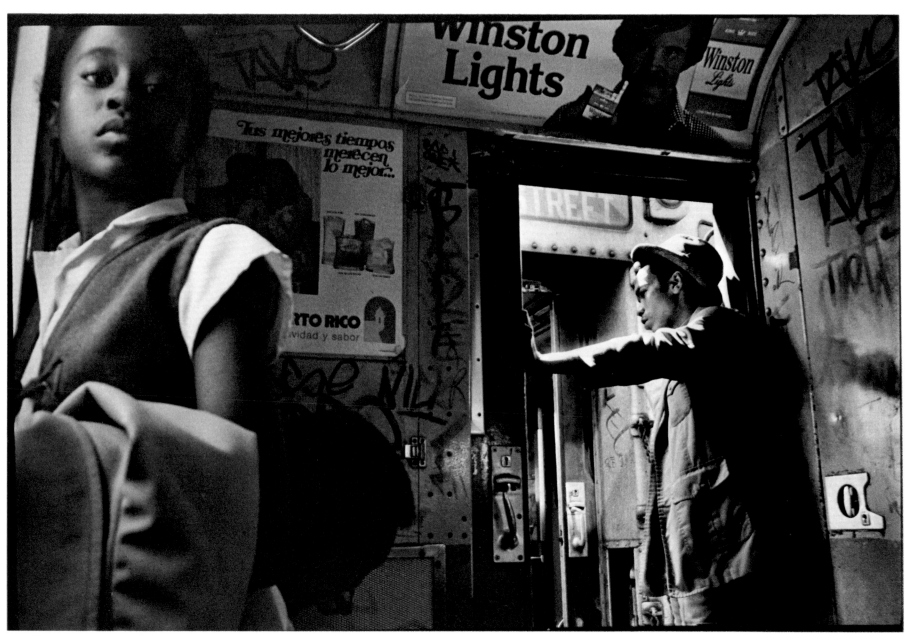

IRT ②, New York City, 1980

Books by Danny Lyon

The Paper Negative. New York: Bleak Beauty, 191 Chrystie Street, New York, 1980.

Conversations with the Dead. New York: Holt, Rinehart & Winston, 1971.

The Destruction of Lower Manhattan. New York: Macmillan Publishing Company, 1969.

The Bikeriders. New York: Macmillan Publishing Company, 1968.

The Autobiography of Billy McCune, edited by Danny Lyon. San Francisco: Straight Arrow Books, 1973.

The Movement, Danny Lyon, contributor. New York: Simon & Schuster, 1964.

Films by Danny Lyon

"Dear Mark" (*A film for Mark diSuvero*). New York and France, 1981. Distributed by Bleak Beauty, New York. Black and white and color, 16-mm., 15 minutes.

El Otro Lado. Mexico and Arizona, 1978. Distributed by Bleak Beauty and The Museum of Modern Art, New York. Color, 16-mm., 60 minutes.

Little Boy. New Mexico, 1977. Distributed by Bleak Beauty and The Museum of Modern Art, New York. Color, 16-mm., 54 minutes.

Los Niños Abandonados. Colombia, South America, 1975. Distributed by Serious Business Company, Oakland, California. Color, 16-mm., 63 minutes.

El Mojado. New Mexico, 1974. Produced by J. J. Meeker; distributed by Serious Business Company, Oakland, California. Color, 16-mm., 20 minutes.

Llanito. New Mexico, 1971. Produced by Danny Seymour's Sensory Overload; distributed by Bleak Beauty and The Museum of Modern Art, New York. Black and white, 16-mm., 51 minutes.

Social Sciences 127. Houston, Texas, 1969. Distributed by Serious Business Company, Oakland, California. Color, 16-mm., 21 minutes.